Norman Sanders
Photographing for Publication

R. R. Bowker Company
New York and London

Portions of *Black & White Prints for Reproduction* originally
appeared, in shortened form, in *Photomethods* magazine.

Passages from the author's *Graphic Designer's Production
Handbook* are reprinted with permission of Hastings House
Publishers, New York.

Library of Congress Cataloging In Publication Data

Sanders, Norman 1927–
 Photographing for Publication

 Bibliography: p.
 Includes index.
 1. Photolithography. I. Title.
TR940.S27 1983 686.2'325 83-17917
ISBN 0-8352-1733-7
ISBN 0-8352-1734-5 (soft)

Published by
R. R. Bowker Co., 205 East 42nd Street, New York, N.Y. 10017.
Produced by
Mark Iocolano/October Press, Inc., New York, N.Y.
Edited by
Gladys Frank.
Designed by
H.L. Chu and Michael Kenna
Special photography by
Brad Hess
Drawings by
Kuan Chang, Michael Kenna, and Benjamin Perez
Jacket designed by
H.L. Chu/Photography: Peggy Barnett.
Printed by
Sanders Printing Corporation.
Bound by
Sendor Bindery.
Manufactured in the United States of America.

Contents

Preface

The first section of this book, devoted to the reproduction of black & white photographs, grew out of a series of lectures I presented to professional photographers and graphic designers under the auspices of the National Endowment for the Arts. Seminars were conducted on the campuses of Yale, UCLA, and IIT among others. Each lecture was followed by a practical question-and-answer session, and during this segment participants almost invariably wanted me to talk to them, from my perspective as a lithographer, about the reproduction of color images as well as black & white. Such questions as "Why doesn't the printer simply match the transparency?" "Which color film reproduces best?" and "What is a scanner, anyway, and how can it help me?" led to invitations to address professional photographic groups and present programs with virtually a total emphasis on color reproduction.

When the opportunity arose to publish the content of these lectures in book form, I was faced with two options in the organization of the material. On the one hand it would be possible to combine the two subjects of black & white and color from the start. It would avoid repetition. But the constant ping-pong from one medium to the other could be tiresome and confusing. On the other hand, I could treat the material as separate, closely related subjects, as they were originally presented in my talks.

I selected the second option because I feel it offers you a more practical sourcebook, where you may read sections of particular interest without the distraction of momentarily irrelevant information.

You may notice as you go through the text that there is an occasional redundancy. It is intentional. It serves the purpose of providing complete answers to your questions when you consult a specialized segment of the book.

I recommend that you start with the black & white section, even though the major emphasis of your work may be in color. It contains background material that will broaden your understanding of the subsequent information.

There are standards and methods of procedure set forth here that will be accepted by some readers and resisted by others. The very least each of you will come away with is a vocabulary and perception that will open avenues of communication between you and the people who reproduce your photographs in print. That alone will extend your control over the quality of your images far beyond the door of your darkroom.

Black & White Prints for Reproduction

Introduction

A common feeling among photographers is that printers are either very stupid or very hostile. And small wonder!

When your black & white photographs are reproduced with veiled-over values where you expected glistening highlights, and flat, dark blotches where you thought vibrant shadows would appear; when your brilliant color prints or transparencies are reduced in print to poor, pale ghosts of themselves, with all the sparkle and contrast and color purity drained out of them, it's natural to blame the printer.

Actually you may be right about a particular printer; there are clods in every business, and you may have run into one. But the chances are that you have yourself unwittingly set the stage for failure.

If your participation in a design project is limited to submitting photographs and then waiting to see "what they have done to your work this time," you are rarely in for a pleasant surprise. Since it is the printed sheet and not the photograph that is the ultimate goal of your effort, you can't afford surprises; what "they" do and what they are unable to do is of utmost concern to you. To succeed in your business, you have to familiarize yourself with theirs—its capabilities and strengths, as well as its limitations, weaknesses, and inconsistencies.

It is possible to bridge the gap between the dynamics of your photographic technique and the constraints of the lithographic process, to preserve a sense of direction and control in your work, to maintain a feeling of identity with the finished product—its impact, its

quality, its success in solving the problem assigned to it. What it takes is knowledge and adaptability. Just as you respond in style to the copy and design of a given assignment, you must accommodate in method to the technology of the lithographic process.

On the pages that follow you will find an introduction to this technology, first as it pertains to black & white photography, then as it relates to images in color.

Often, you are going to be reminded of the limitations of graphic-arts reproduction methods. They are considerable. A black-ink impression is not as black as the darkest shadow in a black & white photograph, so contrast and definition are jeopardized. Colored inks lack the chromatic purity of the dyes in a transparency or color print, so in the lithographed image, color gamut and saturation are reduced. Printing paper reflects only a limited range of the light incident upon it as compared to the luminance transmitted through a transparency, so color brilliance is reduced and density range is vastly compressed in the reproduction. Introduction of the halftone screen compromises image detail and sharpness in both black & white and color images. And the very mechanics of the press create additional distortion of tone.

These limitations are formidable, but they do not become insurmountable obstacles when you cope with them from the start. You have to establish new standards for judging your photographs—standards sensitive to lithographic realities as well as to aesthetic principles. In addition, since your images will undergo quality-robbing effects in

reproduction, you have to arm yourself with the practical information that will give your work a fighting chance to survive intact.

There is nothing unique about this information. What is unique is a discussion that treats this subject as the mutual concern of photographers and printers.

We are going to get into areas of opinion. You may disagree with some of my statements, but I want you to think about them. I am going to recommend a kind of camera that is best, a kind of film that is best, a kind of photographic paper that is best, even—believe it or not—the color of mounting board that is best, because every device and material you use can have a dramatic effect on the quality of the reproduction.

This book is not in any way a discourse on aesthetics. No matter what your personal style, no matter what the content of your images, you can show them to best advantage in printed reproduction only by observing the rules of the lithographer's game. What those rules are, why they exist, and how to comply with them are the subject of this text.

How three different printing processes—letterpress, gravure, and (the most common) offset lithography—are used to reproduce images; What happens in all three processes to the photographic tonal scale.

Chapter 1

The Printing Process: Methods in Current Use

Of the several printing processes in use today, the three most common are letterpress, gravure, and offset lithography. Each is characterized by a particular type of printing plate and by a particular method of transferring ink to paper. All are handicapped in an important respect: there is, as yet, no commercially feasible way in which they can create a scale of continuous tone in the reproduction of an image. The apparent grays are made up of constellations of black dots varied in size or assembled in varying densities on a white or colored ground.

In letterpress, ink is applied to the raised surface of the plate and is subsequently transferred directly to the press sheet. Although the process is far more precise and complex than that of using a simple rubber stamp, the principle is similar. The plate required for image reproduction is called a photoengraving, although it may as well have been named a photoetching. First, a film negative of the image (which has been broken into various-sized dots) is contact-printed onto light-sensitive metal. Then the metal is etched so that selected areas—the spaces between the

dots—are lowered. The lower portions of the plate do not come in contact with the ink rollers or the paper during printing.

In gravure printing, it is the intaglio, or sunken image, surface of the plate that receives the ink and deposits it onto the sheet. The plate is cylindrical in form and incised with tiny wells—90,000 to the square inch. Usually the wells are of a constant size but vary in depth, so that the modulation of tone on the printed sheet is created not with dot size but rather with ink volume. The gravure printing sequence begins when the image on the plate is charged with ink that fills the wells. Then a device (a doctor blade) squeegees the excess ink from the plate surface, leaving only the wells filled. It is from these myriad wells that the ink is transferred to the press sheet.

The most popular printing method currently in use and the process by which this book has been reproduced is offset lithography, often referred to as offset, photo offset, or litho. In offset lithography the image on the plate is neither raised (as in letter-

press) nor recessed (as in gravure) but is virtually flat. Although the image and nonimage areas on a lithographic plate are on a common plane, only the image area is inked as the press is run. One thing more: in offset the plate never comes in contact with the paper, as you will understand as we proceed.

Each of these processes has its advantages; the choice between them for any job is based upon such factors as plate cost, production schedule, length of run, paper options, ability to make changes, and tonal-range capability.

Probably 90 percent of your work will be reproduced by offset lithography, so the discussion in this book is limited to that process—what it looks like and how it works, what its limitations are, and what the lithographer needs from you in order to produce an effective reproduction of your image. Finally, some good news: although the particular idiosyncrasies of lithography will be explored here, the criteria for photographs that are to be reproduced in print apply to all three printing methods. In this regard, at least, your technique need not be altered just to accommodate the press.

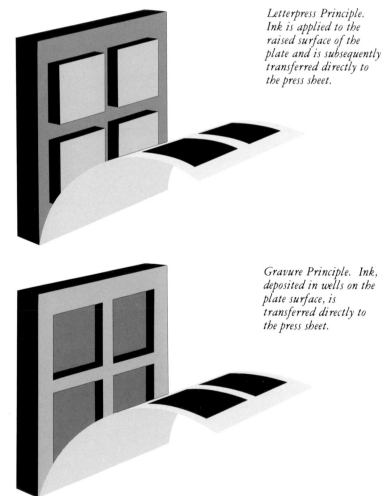

Letterpress Principle. Ink is applied to the raised surface of the plate and is subsequently transferred directly to the press sheet.

Gravure Principle. Ink, deposited in wells on the plate surface, is transferred directly to the press sheet.

What the basic tools and mechanics of the lithographic process are; How reproduction quality is affected by the nature of the halftone screen, dot gain, ink limitations, and paper characteristics.

Chapter 2

Offset Lithography: Principles and Problems

The illustrations on these pages will help you visualize the offset process. The photograph (page 15) of part of a lithographic plate shows a smooth aluminum sheet on which images (illustrations and type) have been made by contact exposure (through an assembly of lithographic films called a flat) and subsequent development. The areas that carry the image and the areas that are blank are essentially at the same level, but they differ in an important respect: the nonimage areas are water receptive; the image areas are not.

Notice in the photograph that the image on the plate is not reversed; you don't need a mirror to read the words. This tells you that the lithographic plate does not make a direct imprint on the printing paper; there is an intermediate process.

The schematic of a lithographic press (next page) shows the plate wrapped around the top cylinder of a three-cylinder stack. With each revolution of the cylinder the plate receives a charge of water that washes over the entire plate surface but adheres only to the nonimage areas. The entire

plate is then skimmed by the ink rollers. The image accepts the greasy ink film, but since the nonimage areas are carrying a water film, no ink is deposited there.

The inked image is then transferred to a rubber sheet called a blanket, which is wrapped around the middle cylinder. The blanket transfers— offsets—the image to the press sheet as the paper is squeezed between the blanket cylinder and the bottom cylinder in the stack.

Each revolution of the cylinders produces one printed sheet and, in this configuration of press, prints one color and on one side only. Printing another color would require another pass, and printing the other side would require turning the paper over and running it through again. But there are various-sized sheet-fed presses, some of which can accommodate printing paper over six feet wide, that are not so limited in function. Some are multicolor presses that have as many as six such "printing stations" and accomplish in a single pass through the machine what would require a half dozen

The Halftone Screen

passes through single-color equipment. Others, called perfector presses, are capable of printing one or more colors on *both* sides of the sheet in a single pass.

Another design—the web press—prints a continuous ribbon (web) of paper on one or both sides in several colors and, at the final station, cuts the web to a given sheet size and then folds and binds the sheets.

No matter what the offset-press design, all commercial lithography today employs a blanket to offset an image received from a plate onto the paper. Printing on the paper from a resilient blanket rather than directly from a rigid plate allows the lithographer to reproduce finely detailed images on uneven or rough paper surfaces with greater fidelity.

The choice of press for a particular job is influenced by five interrelated considerations beyond that of press-sheet dimensions. They are image quality, number of colors, length of run, production deadline, and cost. Large-quantity, tight-deadline projects, for example, can be produced most quickly and economically on web presses. But the matter of their image quality when compared to that of sheet-fed presses is the subject of considerable debate.

What are the variables that affect quality in offset reproduction of your photographs? The four most important are the nature of the halftone screen, dot gain, ink density, and paper. Let's take them one at a time in that order.

Description and Function. I said earlier that the plate is divided into two types of surface—segments that will accept ink and segments that won't. There is no area of compromise. In lithography we can't create gray with black ink by depositing half an ink film on local areas of the plate. The entire image surface accepts and transfers a uniformly thick ink film. So, we create an *illusion* of gray by making the negatives for the plate in a special way. We use a halftone screen, a device that allows us to break the picture into patterns of various-sized dots. When visually fused with the unprinted areas of the paper, the various configurations of dots give the illusion of various shades of gray.

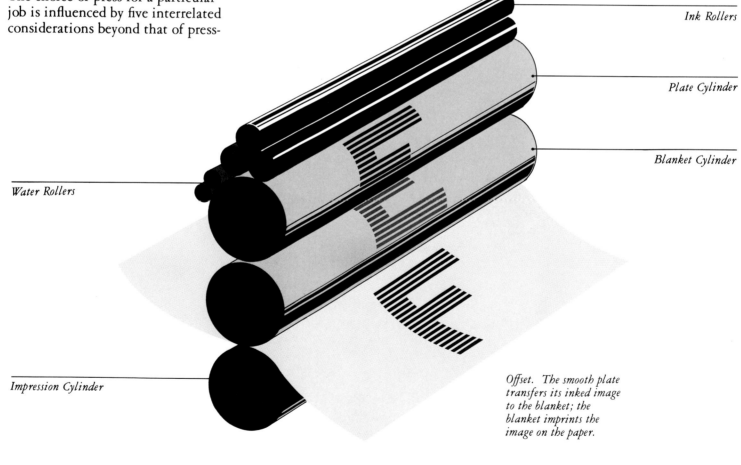

Ink Rollers

Plate Cylinder

Blanket Cylinder

Water Rollers

Impression Cylinder

Offset. The smooth plate transfers its inked image to the blanket; the blanket imprints the image on the paper.

Usually, a halftone is made by photographing a print through a contact screen, so called because it is in contact with a high-contrast lith film during exposure. The contact halftone screen is a very precise dye-image pattern on a sheet of acetate or similar transparent support material. The pattern resembles a checkerboard in that it consists of alternating dark and light patches. Each tiny patch (there are 133 of them to the linear inch in the average screen) is a kind of vignetted density filter. Density peaks at the center of a dark patch and is weakest at the center of a light one. During the lithographic camera work, light reflects from the photograph and is filtered through millions of these minuscule density scales. With appropriate exposure, the light reflected from the whitest highlights penetrates *all* but the densest pinpoint centers of the stronger filters; the light from the darkest shadows penetrates *only* the pinpoint centers of the weaker filters. Between extremes, light comes through larger or smaller areas of the filters depending upon the amount reflected from the various image tones. In this way the continuous tones of the print are broken down and appear on the high-contrast halftone negative film as various-sized dots, either clear or black. Since the centers of all the little filters are equidistant, the size of each dot is in inverse proportion to its surround.

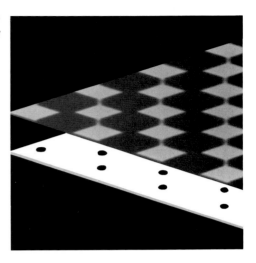

Light reflecting from the darkest part of an image is transmitted only through the thinnest areas in the contact screen. Small dots are created on the negative. Most of the film area remains unexposed and blank. It will reproduce as a black mass with small pinpoints of paper showing through.

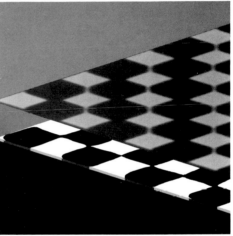

Light reflecting from a middletone is transmitted through a larger area of each screen sector, creating a larger dot area on the negative. This, in turn, will print as a middletone on the plate and paper.

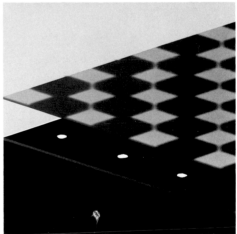

Light reflecting from the highlights is transmitted through all but the densest part of the contact screen's pattern. The film is almost totally exposed, and the small clear areas in the negative will reproduce on the plate and printed sheet as pinpoint dots in the highlights.

Offset Plate. Note that the image is not flopped; it is not printed directly from the plate onto the press sheet.

Thus, the tiniest clear pinpoints on the negative have the largest amount of blackness around them; the larger the clear dots grow, the smaller the black interspaces become until only pinpoints of black appear in a clear field.

The accompanying illustration shows a segment of a halftone that has been considerably enlarged to let you see the effect of the process on an image. If you look at this illustration from normal reading distance, then from a distance of two or three feet, you will see how the human eye creates a gray scale from various configurations of blacks on a white ground. The blacks correspond to the image surface of the plate, the whites to the nonimage (nonprinting) surface.

William Henry Fox Talbot (1800-1877), the man credited with the invention of negative-to-positive photography and printmaking, was also the genius behind some of the earliest experiments in halftone reproduction. Basing his tests on the premise that it should be possible to reproduce an image of many tones while transferring a uniform ink-film thickness, he concluded that the image on the plate had to be composed of fine dots, varying only in size. His original dot-producing devices—halftone screens—were made of folded gauze. A continuous tone negative was placed on top of the gauze, and the sensitized plate was exposed through the two. Later his screens were glass sheets inscribed with a network of fine lines. Beginning with Fox Talbot's work in England and progressing through a century of refinements originating in France, Germany, and the United States, the halftone process has become an increasingly accurate device for the reproduction of photographs.

Lithographers have gained immensely in the ability to manipulate and control tone through the use of the graphic-arts camera and the halftone negative, a method that has replaced earlier techniques of contact printing directly onto the plate from a continuous-tone negative. We have been freed from the problems of cumbersome, costly glass halftone screens by today's lightweight, easily handled contact screens. We have mastered a technology far advanced from Fox Talbot's early invention, and other innovations may be expected. Even continuous-tone lithography (no dots at all) is a reality, though at this stage it is not a truly practical process.

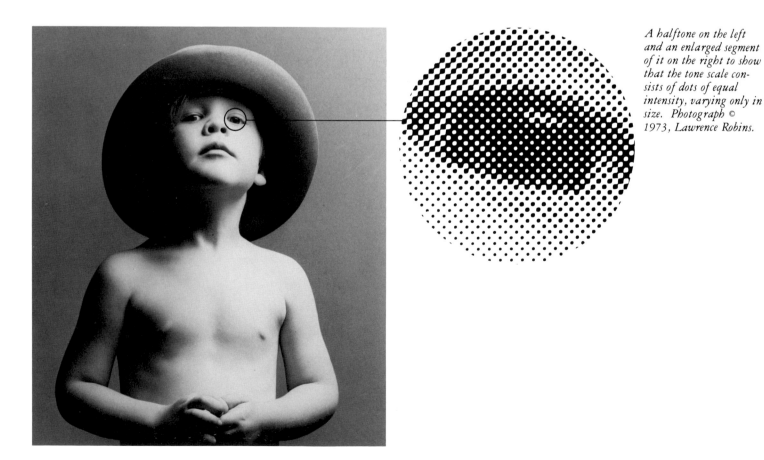

A halftone on the left and an enlarged segment of it on the right to show that the tone scale consists of dots of equal intensity, varying only in size. Photograph © 1973, Lawrence Robins.

Improvement of the contact halftone screen is still the focus of considerable research as part of the effort to increase fidelity to the original print. The shape of the dots and screen fineness are just two of many screen characteristics that are being explored.

Dot Shape. Much of the modeling and weight in an image resides in the middletone portion of the scale: the values in a halftone reproduction characterized by "the 50 percent dot" and tones slightly lighter and slightly darker than this. From a conventional square-dot halftone screen, the 50 percent pattern, which is easily seen with a 10-power magnifier, is one of evenly divided rectangles of black ink and white paper—a checkerboard of dots. It is in this 50 percent dot area and in slightly lighter middletones that the dots either join others at all four corners, or disconnect simultaneously at all four corners. And it is here that the quality of an image is seriously reduced: a sudden tone break appears in the reproduced image; the middletones become coarse, blotchy and crude. For years this was an expected and accepted limitation of the halftone process.

Then about 1960, Eastman Kodak introduced a halftone contact screen that produces elliptically shaped dots. In the middletone range, these dots first join at two diagonal corners, then later at the other two, *not* at all four corners simultaneously. The effect is a smoother transition of grays in this vulnerable part of the tonal scale. This phenomenon is of particular value in maintaining a smoothness in flesh tones and even in subduing the original print's graininess and small blemishes.

The photograph reproduced here with both a square-dot and an elliptical-dot screen provides a comparison. Note the subtle but important differences

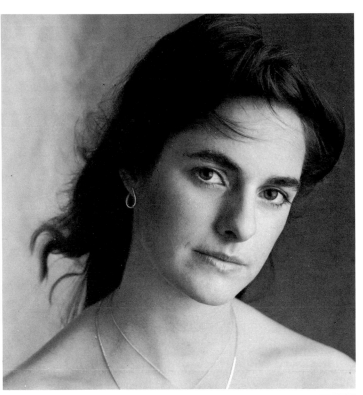

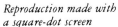

Reproduction made with a square-dot screen

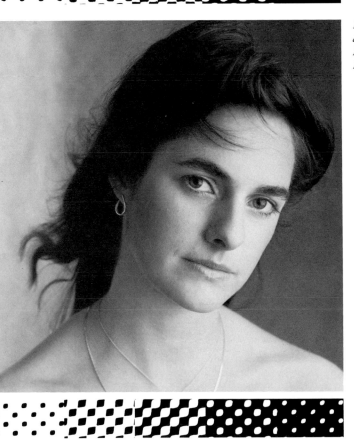

Reproduction made with an elliptical-dot screen
Photograph © 1983, Lawrence Robins.

in the blending of the middletone range. There is, incidentally, no additional charge for providing elliptical-dot rather than square-dot halftones.

Problems occur with the use of the elliptical-dot screen, however, when presses are operating at less than peak efficiency. A press that creates even a slight dot slur while printing will produce a recognizably inferior image, muddy and lacking in middletone definition, when the halftone has been made with the elliptical-dot rather than the square-dot screen. Sadly, if a printer's equipment is not properly maintained, there is little you can do about it.

Screen Fineness. When a halftone screen is used, the number of dots it creates is the same in the highlight, middletone, and shadow areas of the scale, and so is the distance from the center of one dot to the center of the next. The number of dots to the linear inch is referred to as screen fineness, and much of today's lithography is produced with 133-screen and 150-screen devices (133 or 150 dots to the linear inch).

Coarse screens (65 and 85, for example) produce a halftone that may be seen by the unaided eye as a pattern of discrete dots, and the depicting of fine detail is very limited. At the other extreme, with ultra-fine screens (200 and 300) the dot pattern is virtually invisible and there is far better reproduction of minute image detail. But even with the finest screen, the gray scale is really an illusion—just black dots on white paper—and a sharp edge in the photograph is reproduced as a zig-zag of those dots, rather than as a clean, crisp line.

Ultra-fine screening, despite its obvious advantages, is not always the best choice, since the halftones present three problems, all pertaining to contrast. First, in the highlights of a 300-screen reproduction, while each pinpoint dot may be the same diameter as the highlight dot in a 150-screen halftone, there are twice as many of them, so the highlights are grayed and total contrast is lessened. Second, shadow detail is difficult to maintain because the ever-present problem of press pressure, which squashes and enlarges the halftone dots during printing, is compounded by the vastly increased number of dots. This enlargement, called "dot gain," affects the entire image, but is most noticeable in the darker half of the scale, where it results in a loss of tone separation—shadow contrast. And last, a lesser amount of ink must be run in order to avoid overloading

the small dot surfaces, thus reducing ink density and total image range. Still, properly used, especially in double-black duotone printing, a technique I will discuss later, ultra-fine screens can produce images that are stunning.

If you are curious about the screen fineness of various reproductions, you can buy, from graphic-arts supply firms and some art supply stores, something called a "Halftone Screen Determiner." When you place this device on a printed picture, it gives an instant reading of the fineness of the halftone screen. Instructions for the use of this simple and inexpensive accessory are usually printed on the item itself.

Screens are not limited to the conventional dot-patterns. Examples of unconventionally screened images are illustrated on pages 20 and 21. Such renderings can be made either by your printer or by a professional photographic lab. In the latter case, the lab will supply you with a print and may also furnish the high-contrast negative from which it was made. Ask for it. Often that negative can be used directly by the lithographer in the platemaking, thus eliminating the time, expense, and possible reduction in image quality that would result from further camerawork.

65-screen

100-screen

150-screen

200-screen

The ability to resolve detail and maintain smoothness increases with screen fineness. Photograph © 1970, Ralph Krubner.

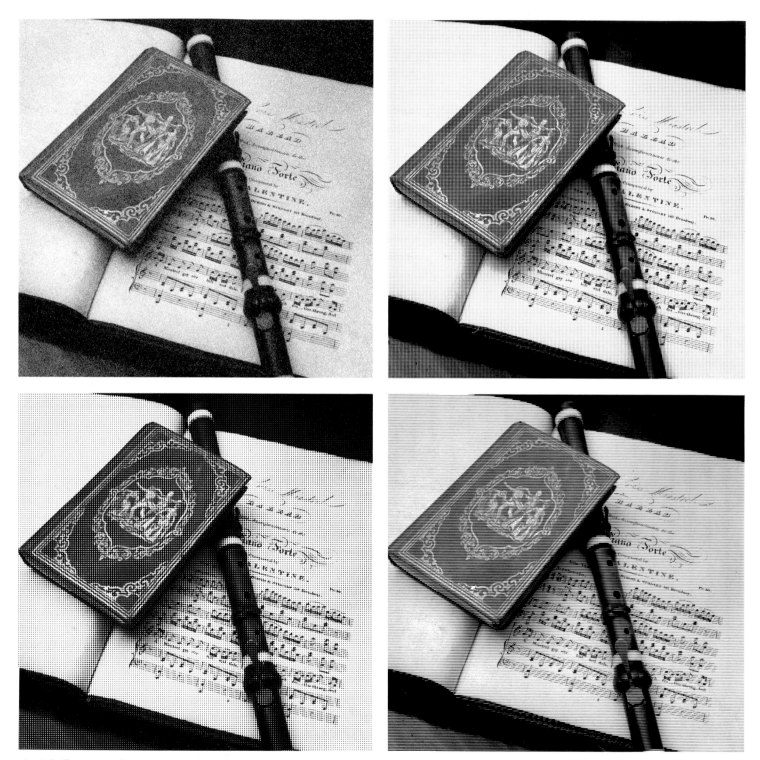

Special effects, some of which were created electronically. These variations were created by Schaedler Quinzel Lehnert Green, Inc., 404 Park Avenue South, New York, N.Y. 10016.

Photograph © 1982, Peggy Barnett; courtesy of Irving Bank Corporation.

Dot Gain

As we have seen, the plate with its combined type and halftone images presses against the blanket, and the resilient blanket presses against the paper. The more uneven the paper surface, the more the squeeze pressure that is necessary. In each case there is some squashing, some increase in the size of the dots, during transfer. This enlargement is called "dot gain" or "press gain." As dot size increases, tone is darkened. And, although all the dots in the halftone are enlarged, the percentage of gain varies with dot size, and this causes distortion of the tonal scale.

Some printers first minimize, then measure, this tone distortion, and compensate for the amount impossible to eliminate by lightening part of the scale during halftone film exposure. Some don't bother. Lack of compensation for dot gain produces images with plugged, featureless shadows and muddy middletones in the reproduction. Overcompensation for dot gain produces images with washed-out highlight detail, or weak shadow values, or both, creating a low-contrast reproduction. A difference of squeeze of even two thousandths of an inch between cylinders can have a significant effect on image quality.

Minimizing dot gain is a complex technical skill. Besides fine adjustments of pressure between plate and blanket and between blanket and paper, other factors must be controlled and balanced against each other. Among these are halftone film and processing materials, platemaking procedure, ink chemistry, additives in the water, blanket resiliency and smoothness, pressroom humidity and temperature, and compensation for paper surface.

Ink Density

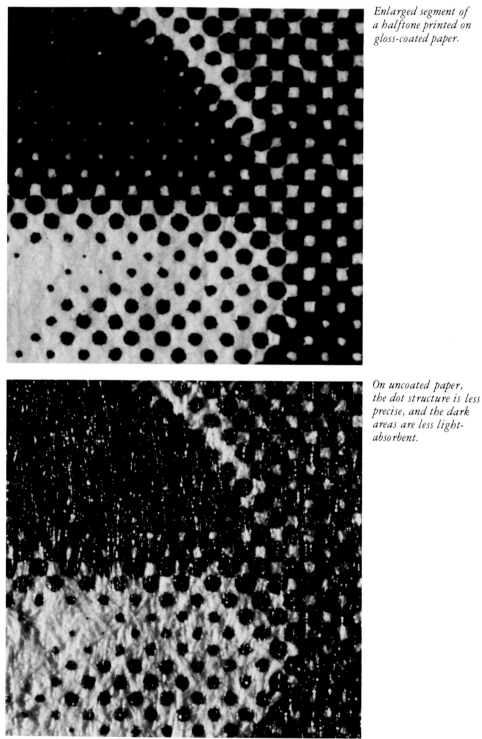

Enlarged segment of a halftone printed on gloss-coated paper.

On uncoated paper, the dot structure is less precise, and the dark areas are less light-absorbent.

An ink layer is deposited on the plate, which in turn deposits some of the ink on the blanket. Then the blanket transfers most of its ink to the paper. Although the blackness is determined in part by the thickness of ink film, there is never a tremendous layer of ink on that paper. In fact the thickness of the ink film deposited on a sheet of gloss-coated paper is about 1 micron (.001 mm), and variations in ink film thickness of even a fraction of a micron may be visually apparent.

All this is easier to comprehend if the maximum blackness in a photograph is compared to the black ink on the printed sheet in terms of light-absorbing capacity—density. (See "Densitometry Refresher," page 57.) Where the silver density of a photographic print may be 2.0 or more, an offset press running an average quantity of an average black pigment on a gloss-coated paper obtains a density of about 1.5. And certainly a thinner ink film or cheaper, low-pigment-content inks produce an even lower density. Thus, the blackness on a printed sheet is far lighter than the blackness of your photograph's darkest shadows.

In addition, the ability of a specific paper to hold ink on its surface affects the density of the image. Uncoated, absorbent stocks allow high press speeds because the ink on them dries quickly. But this same surface absorbency often contributes to the production of low-density black, which translates into washed-out, low-contrast pictures. The maximum ink density on uncoated papers may drop to 1.2—one-half the blackness of ink on coated stock.

Printing Paper

Your lithographer is an important source of information about printing papers and their effect on halftone reproduction. Where, in your darkroom, your photographic paper selection is based upon texture (smooth, fine grained, etc.), brilliance (gloss, luster, matte), weight (single, double), contrast (0 through 6) and, with appropriate developers, image tone (neutral, brown, etc.), a somewhat different set of characteristics is important in selecting paper for lithography.

In choosing a suitable printing paper, you have to consider four qualities: weight, opacity, surface, and color.

Weight. The weight of a paper, closely related to its bulk, or "caliper," is designated by a substance number. In paper used for the pages of books and magazines, that number is the weight of 500 sheets 25" × 38". A book paper designated as Sub. 60, for example, is lighter and thinner than a Sub. 80 paper. Depending upon the particular brand, papers may be available in Sub. 50, 60, 70, 80, and 100 or more. This book is printed on Sub. 100 stock (sometimes referred to as "100-pound" book paper). Among the benefits of using the heavier book stock are greater opacity and the potential for better image quality.

Opacity. Be aware that there are differences in opacity between two brands of the same weight of paper. For a valid comparison don't simply lay a blank sheet of each over a common paragraph of type or other printed surface. That does not take into account the factor of opacity loss through ink absorption. Instead, obtain printed samples of the papers to be evaluated, and compare their unprinted sides for "show through."

Surface. The four most commonly used papers for books that include reproductions of photographs are gloss coated, dull coated, matte coated, and uncoated. The stock for this book is gloss coated and was selected because (under standardized printing conditions) its clay-composition surface (which accounts for about 25 percent of the weight of a premium paper) is capable of the greatest maximum ink density, thus providing a total image density range closest to that of the original photographic print. In addition, its smooth surface minimizes dot gain. However, some people feel that the gloss invites glare, and prefer a coated stock that is not so highly polished, a dull-coated paper. Maximum shadow densities in halftones on dull coated papers are somewhat lower, and dot gain is up a bit. Still, the decision as to which to use is often a matter of personal preference, not really one of cost or of clearcut superiority of one over the other.

Matte coateds are less expensive than gloss- and dull-coated papers, and have about half as much coating for their weight. As a result, ink density and tonal range are reduced and tone distortion (dot gain) is increased. Although less coating often means a less suitable surface for fine halftone reproduction, most of the paper's total weight is fiber, so matte coateds are usually stronger papers. This combination of economy and strength (at some sacrifice in print quality) makes matte coateds a preferred choice for textbooks and some catalogs.

Paper Attribute Comparison

Characteristic	Gloss Coated	Dull Coated	Matte Coated	Uncoated
Long density-range potential	A	B	C	D
Intense ink-color potential	A	B	C	D
Low dot gain	A	B	C	D
Ability to maintain shadow-tone separation	A	B	C	D
Low glare	D	C	B	A
Resistance to cracking on folds	D	C	B	A
Economy	C	D	B	A
Opacity and bulk for equivalent weight	D	C	B	A
Color and texture options	B	C	D	A
Accommodation to the finest halftone screens	A	B	C	D
Strength	D	C	B	A

A = greatest, D = least

Since variations between brands of the same paper type make a single assessment impossible, this summary is only a guide. For a more precise and detailed comparison, consult your lithographer.

To Summarize

Uncoated papers, as the name implies, have no clay or plastic outer layer. Because of this, they are the most absorbent papers and therefore have the lowest density-range and contrast potential. Their rough surfaces require the greatest pressure during the press run, resulting in the greatest tone-scale distortion and loss of shadow detail. The more uneven and absorbent the paper, the more fidelity of image reproduction is sacrificed. But uncoateds are glare-free and strong and are most appropriately used when reproducing nonphotographic art such as pencil sketches and wash drawings. Renderings of this kind appear best on a stock that approximates the artist's paper, and since drawings often have a lower maximum density than printing ink, they do not suffer tonal-range compression in reproduction.

Among each of the four kinds of paper surfaces are many brands to choose from. Each brand has subtle differences in brightness, smoothness, opacity, weight, caliper, and texture.

Color. The color assortment is greatest among uncoated papers. But even among the coateds various hues are available, as well as the more popular white, cream, and ivory. In all cases, colored paper increases highlight density and therefore reduces total image contrast, though it may lend an aesthetic value that makes it worth the compromise.

A skilled lithographic cameraman can lessen the undesirable effects of less-than-optimum papers by altering local and total contrast when shooting the halftone. For this reason, decisions regarding stock weight, surface, and color are made before any halftones are shot.

There is no need for the photographer to alter his printmaking radically to accommodate a particular book paper, but his selection of appropriate prints should be guided by certain rules once the printing paper has been chosen. Primarily, long-range photographs that are rich in detail fare best on the gloss coateds. Uncoateds require prints with far more shadow tone separation, most definitely *not* prints made from "pushed" negatives.

A halftone image is not so much a reproduction of a photograph as an interpretation of it. The halftone screen creates only the illusion of a gray scale. It is a valuable but very imperfect tool that reduces image sharpness, subtle tonal modeling, and fine detail. The offset press too, by its very nature, distorts the tonal scale. And a single layer of black ink on paper cannot match the local contrast and tonal range of a well-made photograph.

The greatest fidelity to the original print requires a set of factors that are often beyond the power of the photographer to choose. They include a high-intensity black ink; a carefully selected halftone screen; a heavy weight of white, gloss-coated paper; a double-black duotone technique that you will read about later; and a printing plant of proven integrity and superior standards. Most of the time you will have to settle for less.

Why photographs intended for reproduction must have modeled tones, detail in both highlights and shadows, sharp focus, and a controlled density range; How camera format, film speed, and paper choice affect the image; What kind of contrast a photograph must have; Why there are specific rules regarding finishing procedures—spotting, retouching, cropping, and mounting.

Chapter 3

How to Meet the Demands of the Process

For the handsomest possible reproduction of your work under less than ideal conditions, you have to use all the resources you can possibly control. These resources are in yourself—your skills and standards—and in the equipment you use.

Start by setting unwavering standards for any print you make or offer for publication. Four basic qualities are mandatory: modeled tones in centers of interest, shadow and highlight detail, a very sharp image, and a controlled density range. Let me comment briefly on each.

Modeled Tones in Centers of Interest. The area of an image that is its essential focal point must be strongly delineated—even dramatized—with gradations of light. On-camera direct flash creates flat lighting that undermines your efforts, and ceiling fluorescents produce low-contrast, almost shadowless images and faces with raccoon eyes. Take the time to study and use lighting creatively, to present an illusion of a third dimension with careful placement of shadows for modeling.

Both Shadow and Highlight Detail. Don't push your film. More often than not, with underexposure you're simply losing shadow detail, and overdevelopment of film detracts from meaningful highlight detail. Burn in blown-out windows, super-white shirts, and other dead-white diffuse highlight areas when they appear, *particularly at the edges of the image.* Otherwise when the lithographer shoots the halftone and carries tone into those blank areas, the entire light-toned third of the scale will gray down and destroy highlight contrast in the reproduction.

The need for adequate shadow-tone separation cannot be overemphasized. The most effective way to attain it at certain times is with overexposure—exposing your film at one-half or less than its rated speed. This is particularly applicable when using long-toed films (such as Tri-X Pan Professional) outdoors or in other settings where high-flare conditions exist. The overexposure moves the shadows further along the characteristic curve, off the toe to the straight-line portion where luminance

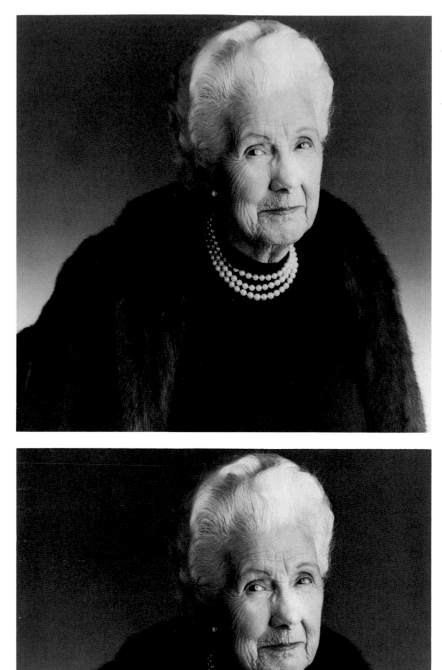

Lack of highlight detail is a common fault in prints. Burn in super-white areas to provide a dimension that cannot be added in the lithographic process. Photograph © 1983, Lawrence Robins.

differences in the scene produce more clearly defined density differences in the negative and subsequent print. Of course, in scenes with medium or long luminance ranges, film development should be reduced to keep the highlight density in check. Luminance-range data recorded from your own tests are the best guide for precise film-development time, but if none exist, reductions of 10 percent to 25 percent from normal are practical starting points. Reductions as great as 50 percent often yield the best negatives for ultralong luminance-range scenes shot in brilliant sunlight.

Along with other considerations, be sure you regularly test your safelights to avoid fogged, low-contrast highlights in your prints. And never forget that full development of properly exposed photographic paper produces a far better print than the dunk-and-squint print development procedures used in some darkrooms.

A Very Sharp Image. The print should be at least the size that will be reproduced, preferably about half again as large, and still look sharp. I don't mean the faked illusion of sharpness created by a blurred negative image printed on a higher than-normal contrast paper grade, but the honest-to-goodness sharpness of a carefully focused, unjolted exposure and subsequent minimal enlargement with a properly aligned and sturdy enlarger, grain focusing device, glass negative carrier, and clean, high quality lens.

A Controlled Density Range. Prints with a density range closest to the capability of the lithographic process

have the potential for greatest tone-for-tone match in the reproduction. It is best to furnish prints with a range of about 1.8 if your photographs are to be reproduced on gloss-coated paper. For publications using uncoated paper, a slightly shorter range and more emphatic shadow-tone separation are appropriate.

An image with a range of 1.3 or less may not be impossible to salvage, but its quality in reproduction will not be great. Furthermore, just as a photograph may have too short a range for excellent reproduction, it may sometimes have too long a range. Such a print requires extreme range compression in the halftone, resulting in a sacrifice of tone separation in the highlights or shadows.

If you don't have access to a reflection densitometer or reflection density guide (and even if you do), I would suggest approximating the 1.8 density range guideline by creating your own control patches at the start of every darkroom printing session. These comparators—also called "spotters"—take only a few minutes to make and, on the appropriate paper, provide a quick indication of the preferred photographic print density range.

First, take a scrap of unexposed paper from the box, develop it normally, then stop and fix it. The swatch will be white: the paper's D/min. The piece should be a couple of inches square and, for ease when using it later, you should punch a hole in it with an ordinary paper punch.

Next, take a second scrap from the box, and grossly overexpose it. Turn on the room's white light, for example. Then process it normally and punch it. This patch will be black: the paper's D/max.

Put both samples in a small water-filled dish near the fix tray, and as you work (using paper for your prints from the same box your spotter patches came from), compare them to the highlights and shadows of your photographs. When, in white light, the lightest highlights are slightly darker than the D/min patch and the darkest shadows are slightly lighter than the D/max patch, the range will be fine.

The intensity of the inspection light near the hypo tray should be low—not more than 40 watts—and a couple of feet from the tray surface. Illumination should be from an incandescent bulb, not a fluorescent tube. As a matter of fact, fluorescents should not be used in the darkroom at all. On occasion their residual glow after they have been turned off is capable of inducing fog in photographic materials.

Prints with a D/min or D/max matching the spotters are devoid of meaningful extremes in tone and should be remade. Be particularly critical when comparing the deepest shadows to the spotter. Bear in mind that images dry darker than they appear while wet, that the eye has difficulty differentiating between dark tones, and that the printing press distorts the shadow values most. Be sure the darkest shadows in the print are more than a borderline step away from the D/max spotter.

Prints altogether too short in scale when compared to the spotters should be remade on a harder paper. Those too close to the parameters should be remade on a lower-contrast grade or with appropriate local burning-in and dodging techniques.

Camera

Your black & white prints are almost invariably enlargements made from your negatives. We find that the greater the degree of the enlargement in your printmaking, the less sharp the image, and the grainier and lower in local contrast (tone separation) the print becomes. These are all bad news in a photograph for reproduction. Logic dictates, then, that you start with the largest *practical* film size when making a shot so that the subsequent enlargement in your printmaking is minimized. Of course, the word *practical* is not to be glossed over, but the almost universal use of 35mm equipment in all shooting situations is clearly inappropriate.

Because of the nature of the lithographic process, the 4 × 5 view camera provides an indisputable advantage over smaller formats in terms of negative size. As you know, a 4 × 5 negative requires about a 3× enlargement to produce the 11 × 14 print usually submitted. In comparison, the 35mm frame requires something closer to a 9× blowup, and when you consider that the average 35mm frame is often cropped to remove extraneous image, a 15× enlargement from this format is not uncommon. The 4 × 5 has other inherent advantages: you have the options of shooting a quick Polaroid to check exposure, lighting, and composition; adjusting tilts and swings at the back to correct or accent visual distortions; tilting or swinging the lensboard to change the plane of focus; and developing a single frame at a time when you want maximum control of negative density range and contrast.

Of course, there is a minus side: a 4 × 5 is bulky; it's awkward and slow to operate and certainly has to be used with a sturdy tripod. Even then, on a windy day, the camera presents a large area to be buffeted, and the focusing cloth snaps menacingly at your eye. Surely, there are occasions when it is impractical, if not impossible, to use a 4 × 5. In that case, select something smaller with the full knowledge that you are trading off something of value out of necessity.

A smaller format is the 2¼ square camera with a negative size that requires about a 6× enlargement to fill an 11 × 14 print area. Many camera models accommodate a Polaroid back for a preview of the final photograph; can be operated at ground, belt or eye level, or even overhead; and boast a selection of lenses that rivals the 35mm format assortment.

In addition, a 2¼ × 2¼ image provides your designer with options in cropping that can best be offered by a square format. Before you get upset about the violation of your image by "that blockhead's cropping," consider the words *commercial photography*, particularly the word *commercial*. Commerce refers to an interchange of goods. You are creating marketable goods, not a personal aesthetic statement. Your photograph must fill a need; it must solve a problem. And it must be subject to modification by the person who uses your product, the designer.

When making a personal photographic statement, the artist or photojournalist is justified in demanding reproduction of his images uncropped. But commercial photography is—corny as it sounds—part of a team effort. And the square format serves that team well. If a layout requires a large vertical rendering of an image available only in the 35mm horizontal format, the subsequent cropping and inordinate degree of enlargement will have a devastating effect on image quality in reproduction.

The last option is the 35mm camera—a fantastic piece of compact equipment. It has available a large number of problem-solving accessories; a nonelectronic model can take hard knocks; and it becomes almost an extension of your thought process when you're working fast and under extreme pressure. But I'd like you to look at your file of commercial work and count how many of the black & white photographs demanded the unique qualities of a 35mm camera because of the fluid or volatile picture-taking situation. I believe you'll agree that the 35mm was often used because of habit and convenience and little else. That easy-to-handle camera, for all its capacity, delivers a negative the size of a postage stamp. The extreme enlargement it requires results in a flat, soft image that is unfit for quality reproduction. It should not be used if a larger-format camera is practical.

Obviously, since no one camera is best in all situations, all three formats should be available.

The greater the degree of enlargement in printmaking, the more may be sacrificed in image quality. Opt for the largest practical film size. Photograph © 1975, Henry Sandbank.

8 × 10

4 × 5

2¼ × 2¼

35mm

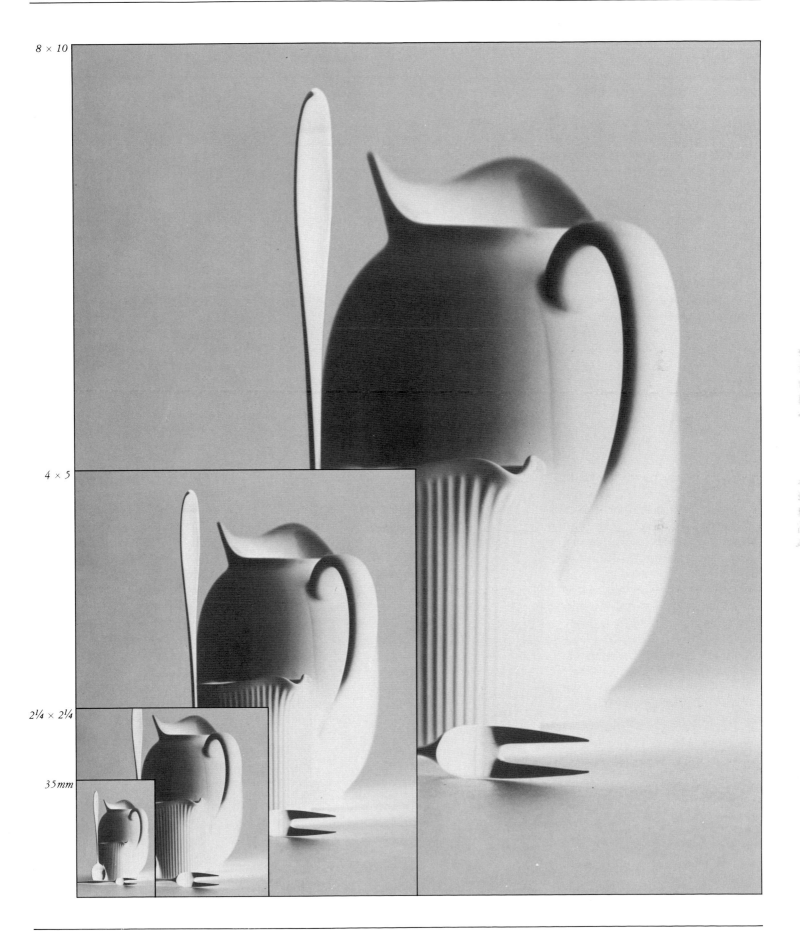

Film

No less destructive to image quality than radical enlargement is a fast and inherently grainy film. I won't belabor the point of practicality: it is far better to get a grainy image than none at all. And it is understandable that the slow films (ASA 50 and less) may be impractical in many cases. A moving subject, reciprocity-failure effect caused by long exposure, and inordinate contrast of the basic material all limit its applicability. But instead of using ASA 400 for *all* assignments, consider the medium speed films as a logical prior choice. With proper exposure and processing, they deliver a sharper image with less graininess better suited to the end purpose: prints for lithographic halftone reproduction.

One thing more: sensitivity to light is a quality built into film at the time of manufacture. There is no magic developer formula capable of increasing the speed of a film significantly beyond what is listed on that little piece of paper we all throw away without reading each time we open a film package. Of course, you may make minor adjustments due to shutter, lens, or meter idiosyncrasies in your own equipment; but if your camera and meter are in top shape, the ASA number on the package of fresh film is a remarkably accurate indicator of the film's speed.

Sometimes photographing in low-contrast situations provides the opportunity to rate the film somewhat higher. But those who feel they can double or quadruple the speed of a film when shooting in normal or long luminance-range conditions and compensate for the underexposure with forced development are clearly in

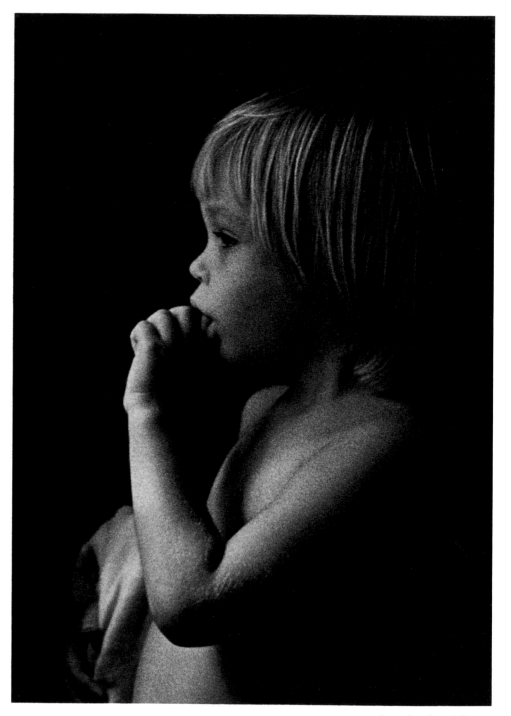

Intentional graininess must be the designer's choice, not his only option. Used with restraint it provides a soft-edged image that may make an important aesthetic contribution. Used all the time, it is a distraction and a bore. Photograph © 1981, Brad Hess.

Photographic Paper: Contrast

error. Pursuit of that myth produces a negative with increased grain, slight increase in negative shadow density that is often lost in the printmaking, and a negative highlight density that you can't get a bullet through, let alone light. The end result is a print that looks like soot and whitewash; it reproduces miserably. To justify such photographs in the name of "style" is an insult to your talent.

If, for some reason, your editor or designer is after a "documentary look," let this be determined before you go out on assignment. You might then decide on a super-speed film and a developer chemistry that accents the grain condition. You might even ask your lithographer for a mezzotint or other special-effect screen. But under ordinary circumstances, the sharp image your lithographer requires is best provided by a photograph low in graininess.

We've found that photographers often use high-speed films because their clients are partial to illustrations that seem unposed, that imply the subject is oblivious to the presence of the photographer. These images are most convincing when they are seemingly devoid of photographer-controlled

illumination. The client might express his preference for this style by requesting "available-light photographs." That request is so specific that the photographer immediately begins thinking about the smallest format and high-speed films.

I believe that in commercial photography the subject is rarely oblivious to the photographer's presence and the clicking shutter. What you want—what the client wants—is not that the images be available-light exposures, but that they *look like* available-light shots. And that is quite another matter. It opens the door (and the photographer's mind) to consideration of bounce flash or a similar stratagem, without sacrificing the film format and speed suited to the demand for sharper, less grainy prints—prints better suited for halftone reproduction.

While on the subject of image sharpness, I would suggest one thing more: carry a sturdy tripod, and use it. There is probably no piece of photographic equipment more awkward to move around with than a good, firm tripod. But I don't believe you can take consistently crisp, nonflash photographs, indoors or out, without one. As a compromise, if a large tripod is impractical, a small sturdy one will do. When the longest leg is beneath the lens of the camera, this type of tripod is remarkably stable. Admittedly, the use of a tripod slows the photographic procedure. But, on the other hand, it provides the photographer with time to think carefully about composition, focus, and desired depth of field. For some reason, looking at an unwavering image in the finder promotes finer work.

Before considering the specifics of photographic papers, let's take a moment to establish a common understanding of what is probably the most used and misused word in the photographic lexicon: *contrast*. I have already made frequent reference to the terms *local contrast* and *total contrast*, but in no context are they more subject to misinterpretation than in their relation to the papers on which prints are made.

The *Focal Encyclopedia of Photography* explains contrast in about 1500 words, with five illustrations and reference to three other entry headings in the volume.

Among photographers, contrast is generally considered a simpler matter. Here, it refers to the density range and the number of intermediate tones in a print. Thus, a print with a long range and few intermediate tones is said to have high contrast, while one with a short range and many intermediate tones is said to have low contrast. Therefore, a print made from a negative that would normally be printed on a grade 2 paper becomes a high-contrast image when printed on hard paper (5 or 6) and a low-contrast image when printed on a soft paper (0 or 1).

To a lithographer, the definition of contrast is different still. He refers to *total* image contrast and *local* contrast. Total contrast is the difference between the darkest meaningful shadow and the lightest meaningful highlight as measured with a reflection densitometer. It is, in other words, the precise density range of the print. Local contrast is an evaluation of tone differences in the highlight third of the scale, the middle range, or the shadow third of the gray scale.

When there are clearly defined differences within the highlight third, the image is described as having good highlight-tone separation, or good highlight contrast. When these tones are flat and ill defined, the print is said to have a low-contrast highlight, no matter how white the tones or how great the total image contrast of the print. The same applies to each of the other thirds of the tonal scale. A print with well-defined shadow-tone separation is described as having good shadow contrast. Solid-black, featureless, shadows are low-contrast shadows, no matter how dark they may be.

For this reason, the word *contrast* must be used with care. The language must specify or clearly imply whether the contrast referred to is total image contrast or local contrast and, if it is local contrast, which third of the scale is being evaluated.

With this in mind, consider two statements frequently heard regarding prints for publication:

Statement #1: "Prints lose contrast in reproduction, so I'm going to make my prints on a harder paper."

Fact: Images lose density range (total image contrast) in reproduction because black ink is not as black as the D/max of a well-made print. They also lose some shadow-tone separation (shadow contrast) because of dot gain. But making a print on a harder paper won't create a blacker black ink or reduce dot gain; it will only reduce the amount of local contrast—the printable image detail.

Statement #2: "Prints gain contrast in reproduction, so I'm going to make my prints on a softer paper to get more detail."

Fact: A negative that would print properly on a normal contrast grade paper does not use the entire response range of a softer paper. When the highlights are correctly placed, the darkest shadows do not approach the paper's D/max and appear washed out in the print. If they are lighter than the maximum density of ink, they will print darker when lithographed, and the total image contrast will, indeed, be increased. But unless there is well-defined modeling throughout the range, local tone separation—detail—will not be enhanced.

Remember, then, that it is not the total contrast that is of primary importance, but local contrast in each third of the scale. Make the print with a density range of about 1.8 and the amount of local tone separation you would like to see in the reproduction. If shadow detail is important, be sure the dark tones are well defined.

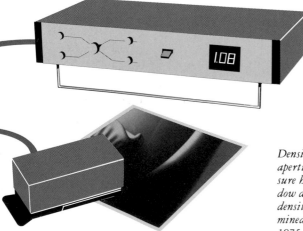

Densitometer. Its 5mm aperture is used to measure highlight and shadow densities from which density range is determined. Photograph © 1975, Henry Sandbank.

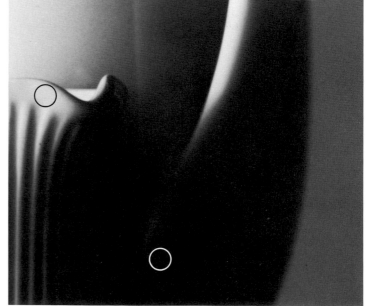

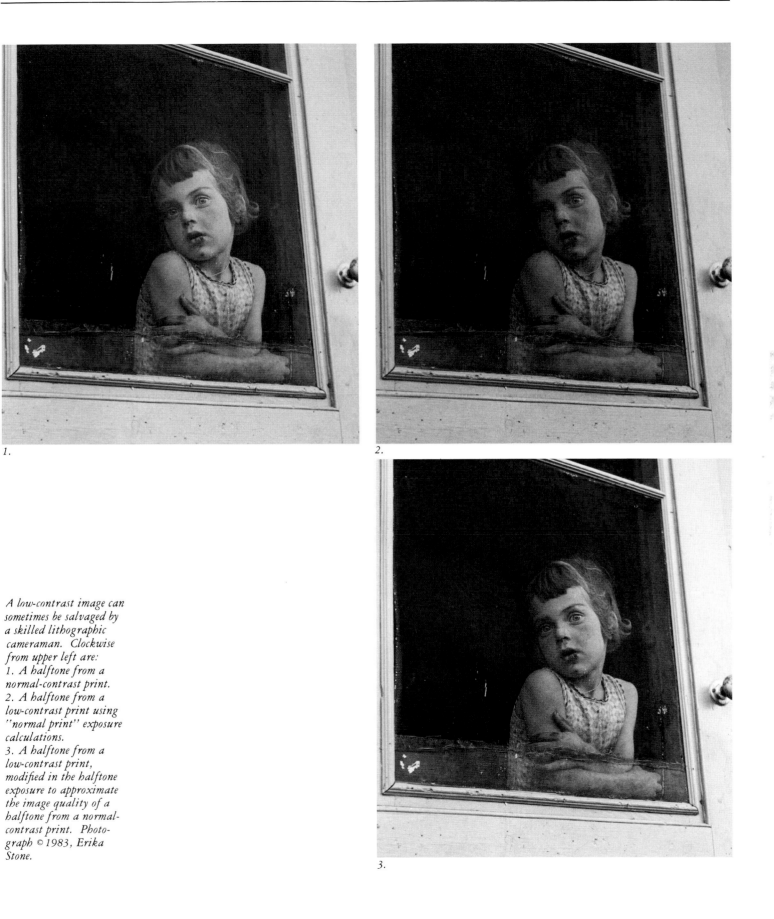

1.

2.

3.

A low-contrast image can sometimes be salvaged by a skilled lithographic cameraman. Clockwise from upper left are:
1. A halftone from a normal-contrast print.
2. A halftone from a low-contrast print using "normal print" exposure calculations.
3. A halftone from a low-contrast print, modified in the halftone exposure to approximate the image quality of a halftone from a normal-contrast print. Photograph © 1983, Erika Stone.

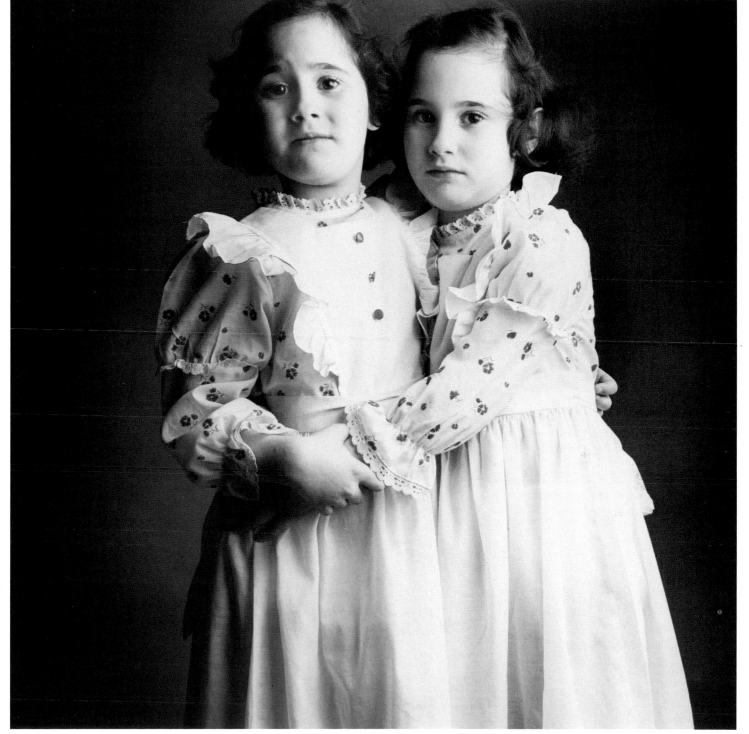

The reproductions on these pages are double-black duotones. Two impressions of black ink extend the halftone's range to one that approximates the original-print range. The two halftone films that are required for each reproduction have vastly different scales to preserve the delicate highlights and to provide middletone separation and strong shadows. Photographs © 1983, Lawrence Robins.

Each horizontal row was photographed with a common exposure. Top row: *Exposure calculations keyed to older woman.* Middle row: *Exposure calculations keyed to man.* Bottom row: *Exposure calcula-* *tions keyed to young woman. Gang shooting—using identical halftone exposures for black & white prints that differ in range and local contrast—compromises quality. Always. Photographs © 1983, Lawrence Robins.*

Photographic Paper Itself

Some papers are not as suitable as others for prints to be published. The matte papers, for example, often yield a short range and compromise shadow detail. At the other extreme are some special "exhibition" papers capable of an inordinately long range—just too much of a good thing when the prints are made for publication. Prints on these papers require tremendous tonal compression in reproduction, again compromising shadow detail, and should be avoided.

Simply put, photographs that reproduce best are black images on smooth, white paper: a Type F paper developed in Dektol or similar chemistry is unqualifiedly recommended. Ferrotyping is unnecessary. Before the lithographer photographs your print, he measures its density range and, based upon that, the image content, and his printing conditions, computes the basic halftone exposure and each of the supplemental exposures. It is true that a ferrotyped print has a somewhat longer density range than an unferrotyped Type F, but the difference is easily compensated for in the halftone exposure computation.

You may have read in Eastman Kodak's useful publication, *Photography and Layout for Reproduction*, that ferrotyped prints are preferable because they produce a bit more shadow-tone separation—that quality most easily lost in lithographic reproduction. Although I respect Kodak's opinion, we've found at our plant that a properly made print on a Type F paper, dried matte, often has a density of 1.8 and sufficient shadow-tone separation for first-rate reproduction and that it does not have the physical limitations common to glossies. We know, for example, that ferrotyped prints are

fragile—subject to surface abrasion and cracking. In addition, their high gloss makes them considerably more difficult for a photo retoucher to work on, because the difference in gloss between the paper surface and his materials makes tone judgment less precise. In the second issue of *Industrial Camera*, Eastman Kodak took a different stand and suggested— as we do—that prints should be made on Type F paper and *not* ferrotyped.

If your lithographer is adamant in his request for glossies, you will have to furnish them. It is possible that he bases his demand on the fact that he has set his camera for a constant halftone exposure, regardless of each print's density range. If that is the case and if his single standard is keyed to the compression of a very long-range ferrotyped print, you had better give him one. But the printer who demands glossies without exception may be telling you a lot about the quality of work you can expect. Such a printer is like a tailor who purports to serve the public at large by manufacturing one size of suit. I suggest you do business with the lithographer who tailors each halftone to fit the density range and subject emphasis of each individual photograph.

The image tone of a Type F paper is black, and the paper surface is white. Lithographers prefer it to some popular papers that have a brown image tone on a cream surface. Though these papers are excellent for exhibition work, they create difficulties in reproduction for two reasons. First, the brown tone scale reproduces with somewhat less

shadow contrast than it seems to have in the print and, unless special care is taken, can reproduce with a hint of harshness that the serious photographer will find disquieting. Second, often the cream paper tint hides the fact that the highlight end of the print's scale is featureless, and the halftone reproduction will make that shortcoming painfully apparent. A black image on white paper is what it is, without camouflage. The photographer, noticing any blank areas, can remake the print, burning in the appropriate details, and spare himself the shock of perceiving the defect—too late—in the reproduction.

Smooth-surfaced papers are preferred because the print is illuminated from the sides during the halftone exposure, and a textured surface could translate with an obvious and disturbing pattern in the reproduction. Type Y paper (silk surface) and others like it are particularly offensive. Sometimes the photographic-paper pattern combines with the halftone-screen pattern to create a moiré effect that virtually destroys image quality. For these reasons, a smooth paper is a must.

A little-publicized characteristic of photographic papers, important to both the photographer and the halftone cameraman because it affects tone reproduction, is not normally considered or controlled by the photographer. I am referring to fluorescence.

Brightening agents are added to photographic paper during its manufacture. Some of these agents, as well as other additives in the papermaking process, *fluoresce* under ultraviolet (UV) stimulation, others *absorb* UV, and still others *reflect* UV. Normally, the photographer's concern is with the overall appearance of the print and, since under normal

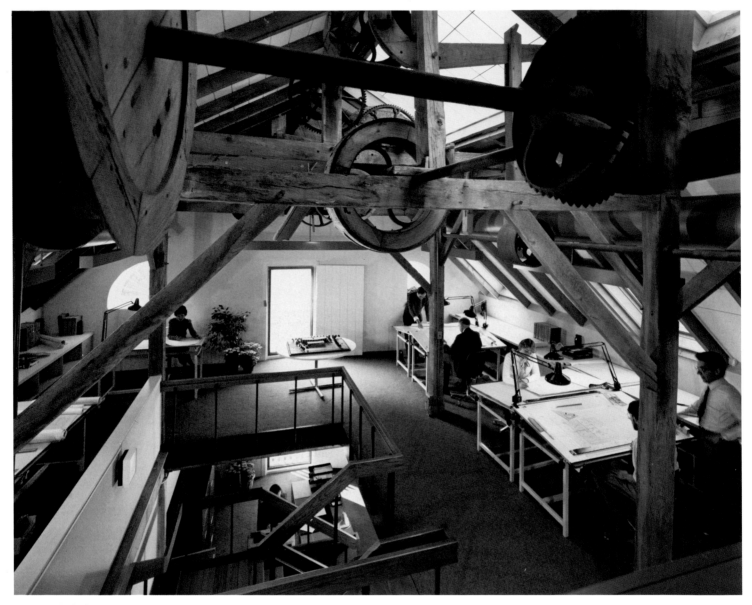

Double-black duotone
also requires individual
exposures for each of the
two negatives tailored to
the print's range and
local contrast. The expo-
sures, called basic, flash,
and bump, *are described*
in chapter 4.
Photograph © 1983,
Ashod Kassabian.
HLW: Van Dorn Mill

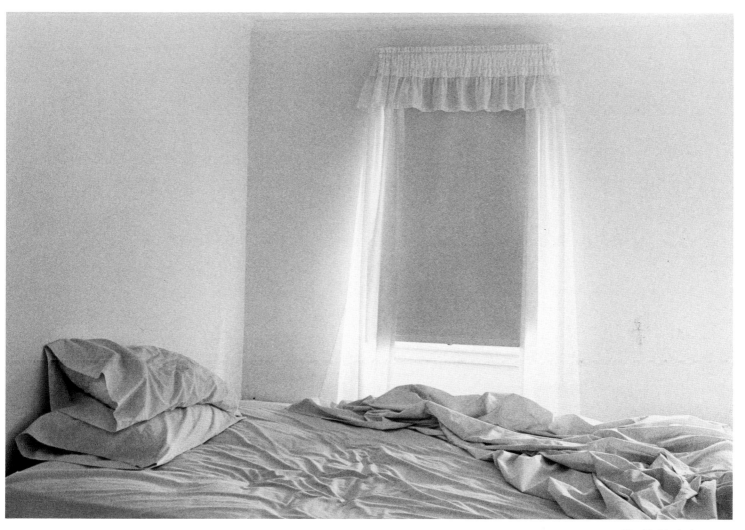

Double-black duotone.
Photograph © 1983,
Lilo Raymond.

illumination he is unaware of a UV factor, it is not an element he considers.

But halftone cameramen often use light sources that emit, along with visible light, a large quantity of UV radiation. Since the visible light is very intense, a cameraman looking at a print in the copyboard is also unable to perceive the effect of the UV factor. The lith film, however, is sensitive to the response of print papers to the UV rays from the light source, and the effect on the halftone rendering is noticeable, mostly in the highlights. For example, an exposure calculated to produce correctly sized halftone dots in the highlights when the photographic paper is UV reflectant would produce recognizably darker halftone highlights if the paper were UV fluorescent; it would produce still dingier highlights if the paper were UV absorbent.

Densitometers, which measure highlight and shadow print densities used in computing halftone exposures, do not include UV variables in their calculations. Common "black-light" examination of the prints prior to halftone shooting only singles out fluorescent papers from nonfluorescent ones, not UV-absorbent from UV-reflectant surfaces. And because the degree of fluorescence among papers that do respond to UV emission varies from one paper to another, the problem is compounded.

Some printers are aware of this phenomenon and cope with it by either placing a UV-absorbing filter at the lens, or putting UV-absorbing transparent material in the light-to-copyboard path. Each has its advantages. Neither solves the problem completely. In better printing plants, before the halftone cameraman begins shooting a series of prints (for a given annual report, perhaps), he may make a test using one or two of the prints to assure himself that highlight values are being rendered as expected. If they are, he continues with the balance of the prints. If not, he reshoots the test prints making changes to accommodate the UV factor, then builds that compensation into the balance of his halftone exposures.

For this reason, it is vitally important that the photographer submit all his prints for a given project on one brand, type, and surface of paper, thereby assuring correct highlight placement in all the reproductions. It is permissible to change contrast grades since UV response is usually the same on all grades of the same paper.

It is the set of prints on a variety of papers that reproduces with the least continuity of style. Even if time and plant policy permit the reshooting of substandard halftone renderings, the delays involved are both frustrating and costly.

To repeat: the UV factor in photographic paper is not usually under the control of the photographer, but its effect on halftone reproduction is significant. It can be compensated for, and that compensation is most likely to be made if all the prints for a given project are on a common type of paper.

It should not be necessary when talking to professionals to warn against writing on the back of a photograph, thereby embossing the emulsion surface; using a grease pencil that smudges onto the face of other prints; or attaching a paper clip to a print and creating an embossed clip mark. Still, we see a lot of prints mutilated by careless handling, and these are probably the three easiest ways to destroy halftone quality short of folding the print.

Attaching a paper clip to a print is one of the easiest ways to destroy halftone quality.

Mounting Board

Another detail: Lithographers rarely have print-spotting dyes on hand for touching up prints before photographing them, and similar repairs to the picture area of the halftone film are expensive and conspicuous. Be sure your prints are completely and competently spotted before submitting them for reproduction.

A final comment on paper: As a lithographer I would judge prints on resin-coated papers to be adequate for reproduction. The gloss papers seem to photograph with a bit less contrast than one might predict, but this can be adjusted in the halftone photography. Resin-coated papers may also present problems for retouchers, particularly in tone bleaching. Still, the prints are, in general, usable. As a photographer, however, I don't like them. I think that printing on resin-coated papers vulgarizes a photograph and robs it of finesse.

Print margins should be trimmed off and the prints should be mounted to rigid board and not matted. Mounting and covering with a paper flap are simple, effective ways to provide image protection during handling. Because matting frames around the print displace the image surface as it is held in the copyboard, they are an obstacle to accurate focus and have to be removed so that the print can be held against the copyboard glass.

The color of the mounting board is important. When you mount the print on a large piece of white board, you are creating a potential flare condition that has the effect (if corrective action isn't taken) of washing out the shadows and flattening the image contrast. If a print is mounted on white board, or if print margins are untrimmed, the lithographer should cover the area surrounding the image with gray paper. But don't assume this will be done; very often it is not.

Certainly black board will eliminate the flare condition, but it introduces an equally undesirable development problem. Usually both your image and some amount of the mounting board are included in the lith-film image. The net effect is that developer activity occurs at a higher rate along the edges of the photograph than in the central portion because the developer is not being exhausted in the area of the halftone negative corresponding to the black mounting board. Often, in the time that the central portion of the image is properly developed, the perimeter has been overdeveloped. For these reasons—to keep the amount of flare constant and accounted for and to equalize the developer exhaustion rate across the entire image—I recommend that you mount your photograph on a medium-gray board. You don't have to be very precise; anything a little lighter than an 18 percent gray card is fine.

There is one notable exception to the rule of mounting all black & white prints. Occasionally instead of a camera, an electronic device called a scanner is used to expose the halftone film. A scanner is a computer used primarily in the production of color separations from transparencies and color prints. A more detailed explanation of it appears in the color section of this book. In preparing a print for exposure by scanner, you must observe two rules. First, the print should not be mounted because it must be positioned around a cylinder. Second, since the scanner cannot accommodate prints as large as a graphic-arts camera can, you should confirm the permissible dimensions before making your final prints.

For best results, black & white prints should be mounted on a medium-gray board. Photograph © 1975, Henry Sandbank.

Concluding Comments

In concluding this section of the book, I'd like to point out a dozen differences between exhibition-print options and the requirements for prints destined for publication.

Paper Surface. With exhibition prints there are no limitations. The surface that contributes most to the aesthetic integrity of the image is the one to select. Prints for reproduction should have a smooth surface.

Image Tone. Again, the choice is limited only by the photographer's taste in an exhibition print. A print for reproduction should have a black image.

Paper Color. The exhibition print may be made on paper of any available color: white, ivory, or cream. The paper for the reproduction print should be white.

Paper Type. Prints you display may be on any type of paper. Reproduction prints should not be on RC paper if bleaching and retouching are contemplated.

Density Range. The maximum density of a display print should be keyed to the level of room lighting; the brighter the room, the greater the acceptable range without significant loss of shadow contrast. The range for reproduction prints should be about 1.8, with more shadow-tone separation than is normally required for an exhibition print.

Size. The photographer's aesthetic judgment determines the size of an exhibition print. As a general rule viewers stand at a distance approximately equal to the print's diagonal dimension when viewing it. Personal, intimate compositions are often small; other subject matter may be quite large. The print for reproduction should be at least the size of the intended reproduction, preferably about half again as large. This specification is subject to modification only if a scanner will be used to create the halftone. When a photograph smaller than reproduction size is enlarged in the halftone camera, loss of both edge definition and local contrast is inevitable. An enlargement made in your darkroom not only precludes this loss, but offers additional advantages. It is easier than a small print to evaluate for image sharpness, less difficult to spot and retouch, and more accurately analyzed with a densitometer when halftone exposure is computed.

Crops. Exhibition prints are cropped or matted to show only the live area; that portion of the image to be displayed. Reproduction prints should show more image area to allow for the designer's cropping and to provide a small amount of nonprinting image to overlap the window on a lithographer's flat.

Paper Variety. An exhibition may consist of prints made on an array of different papers. This is not true of prints to be published. To cope most successfully with the UV factor and maintain a consistency of style throughout a printed piece, all the photographs should be made on one kind of paper.

Mounting and Matting. When a print is to be exhibited, the color and type of mounting board is an aesthetic decision. You are limited only by the rule that the board be acid-free so that print life is not jeopardized. Prints for reproduction should be mounted to gray board. They should not be matted because the print face must be in contact with the copyboard glass of the graphic-arts camera during exposure to assure correct focus and size and to avoid the shadows that a mat would create.

Processing. Archival processing is a serious consideration when prints are to be exhibited and sold to collectors. Normal processing and washing is all that is necessary in a print for reproduction.

Margins. Generous white print margins often enhance an exhibition print. When a print is prepared for publication, the margins should be trimmed off to reduce flare in the halftone exposure.

Spotting and Retouching Materials. Exhibition prints can be retouched with any dye that is accurate in image tone, inert, and not subject to change in color or value over a long period. Prints for reproduction require materials consistent with the UV response of the print paper.

While the demands of the printing process are rigid, the craftsmanship they engender pays off. Prints made properly for publication have a dynamic presence that reflects credit on the photographer in any exhibition situation. Exhibition prints, on the other hand, frequently don't fare that well in publication.

What you should know about lithographic camerawork, unconventional halftone screen effects, duotone techniques, and blackprints; Why you should confer with the lithographer on every job.

Chapter 4

How to Use Your Lithographer's Skills

Although the lithographic process, or at least its limitations, may work against you, the lithographer does not. The appearance of your printed photographs is as important to his reputation as to yours. You will find that the time you spend visiting a plant that is printing your images is an investment that pays off handsomely. There are a number of things a lithographer can do for you if you consult with him. Talk to him about image interpretation; ask him for blackprints; be prepared to meet with him to discuss a job in progress or one recently completed; and explore, with his help, the possibilities of duotones and other lithographic techniques. As you read through the following pages, you will understand these suggestions and be persuaded, I hope, to follow them.

As I have mentioned many times, the density range and local contrast obtained by a single impression of black ink on paper are usually less than those in your photographs. To compensate for this loss, the halftone cameraman must realign the tonal scale when he shoots the photograph.

It is this realignment that largely determines the quality of the reproduced image. Upon analysis of the tonal values and image content, it may be found necessary to compress the entire tonal scale or to realign the scale by enhancing definition of shadow or highlight detail or both.

The precise halftone interpretation depends on individual press and paper characteristics and on an aesthetic judgment often left to the cameraman. Because of this, it is imperative that you or your designer discuss your photographs with the lithographer before work is begun. Prints shown on the following pages demonstrate how the local contrast of an image can be modified during the lithographic camera work. The cameraman can produce many different halftone renderings from a given photograph. The "right" interpretation is simply a matter of knowing the client's taste.

The devices and methods available to the lithographer for the purpose of manipulating the tonal scale are different from those used in conventional photography. As a

photographer, your options for controlling range and contrast in negatives include your film choice, exposure index, lighting configuration, filters, developer chemistry, and development time. But in lithography the differences produced by various lith films and chemistry are not so significant, and it would be impractical to change chemistry for each sheet of film. For a lithographer, lighting of the copyboard surface has the single objective of providing even illumination of the image on the ground glass and film plane. Filters, which may be used in certain circumstances to control contrast, are neither time-efficient nor accurate. And changing the processing time within reasonable limits has no significant effect on contrast. Even if it did, it would be impractical to alter development time for each sheet passing through today's automatic lith processors.

Instead, manipulation of the scale is effected by the use of two or three superimposed exposures of the lith film to create one halftone. There is remarkable flexibility in this technique because of the nature of the basic and supplemental exposures.

Basic Exposure. The basic exposure of the film through the halftone screen provides an unrefined image. If no further exposure were given, the film would provide a recognizable picture but not a particularly satisfactory one. That is because the tonal scale of a photograph is usually longer than the halftone screen can encompass. If the exposure were keyed to the highlights, the shadow areas in the negative would be totally clear, devoid of detail. The dark tones in the original would reproduce as solid, featureless black.

1.

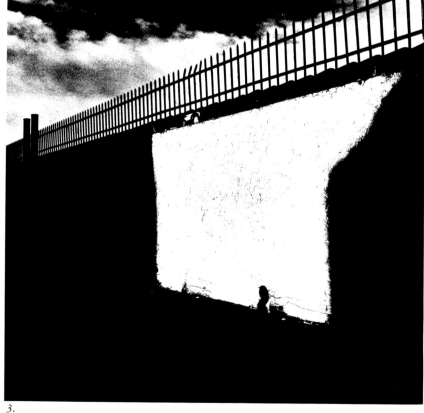

3.

2.

4.

For that reason, before any photography is done, the density range of each photograph is read with a densitometer, the halftone screen's effective range is subtracted from it, and provision is made to record the difference—the excess range—with a supplemental "flash" exposure.

Flash Exposure. The term *flash exposure* is a bit misleading because what it refers to is not an exposure to a brief burst of brilliant light, but rather one that exposes the film for several seconds to a low-level light source. This is the method: with the lith film and screen in place, the camera back is opened, and a nonimage exposure is made with the light source perpendicular to the film surface. Exposure, keyed to the excess range, must be controlled—not enough and the shadows remain empty; too much, and the shadows print as washed-out, lifeless gray. Between these two danger zones, there is a safe range that affords a broad choice of effects.

To control range and contrast in the reproduction, a cameraman may use two or three exposures in making the halftone.
1. Basic Exposure. Highlights are dull, shadows are featureless.
2. Basic + Flash. The supplemental, screened, latensification exposure provides shadow detail in the halftone as it appears in the print.
3. Bump. A short, superimposed, screenless exposure to the copy. Its effect is to brighten and provide tone separation in the highlights.
4. The effect of one set of basic + flash + bump exposures. Each may be modified to alter the final interpretation. Photograph © 1983, T. W. Sanders.

The flash exposure is a type of latensification. Its effect is limited to the dark image tones almost totally, and brings them over the threshold to a developable exposure level while the highlights remain unaffected. The flash exposure provides shadow detail, not by some miracle, but only as it appears in the photograph. It cannot provide shadow detail in the halftone if none exists in the print. For this reason, if shadow modeling is important in the reproduction, it must be defined in the photograph.

The flash exposure can be made before the main exposure or after it; the result is the same. On the other hand, the bump exposure, when needed, is usually last.

Bump Exposure. The highlight bump is a very short exposure to the photograph made *without* the halftone screen in place. The screen is simply lifted off the film after the basic and flash exposures are made and a "line" exposure is superimposed. The bump exposure increases definition of the important highlight detail apparent in the print; it enhances modeling in the upper third of the scale, that important area where the eye is first drawn.

Since, in the very brief, screenless exposure time, no significant light reflects from the shadow end of the image scale, there is no effect at all on the dark tones. Again, exposure must be controlled: too little and there is a negligible effect; too much and the highlights burn out or, since the basic exposure has been shortened to accommodate the supplemental bump, the middletones go muddy. As with the flash exposure, many variations are possible within the safe range between extremes.

In each of the three renderings of this image, the extreme highlight and shadow tones are virtually the same. Manipulation of the tone reproduction curve with precisely calculated changes in the basic, flash, and bump exposures produced three different interpretations. Photograph © 1983, Lilo Raymond.

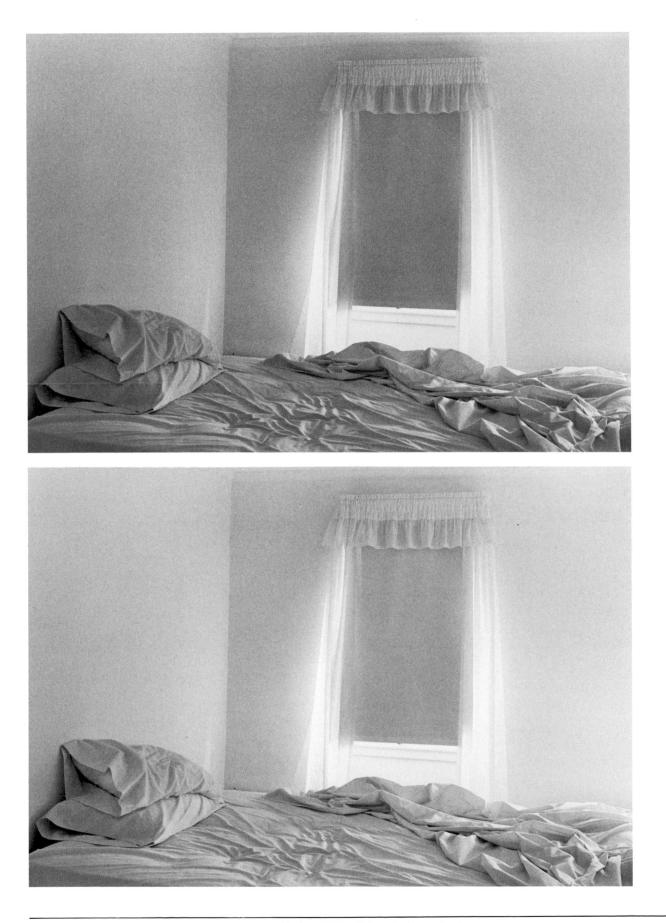

Blackprints and Conferences

Duotones

All the exposures are keyed to the subject matter, the desired interpretation, subsequent dot gain on press, and the ink-holdout of the paper on which the halftone will print. Upon consideration of these factors, the bump exposure is sometimes deemed unnecessary. This does not imply a sacrifice of highlight detail, but it does take into account the fact that the basic exposure is normally biased toward the highlights.

Each of the two or three exposures is based upon a precise calculation and varies in duration according to the rendering desired. Thoughtfully interrelated, they produce a halftone that can salvage a substandard print and even enhance an excellent one.

In order to save time and provide consistent and predictable results, many printers now use small table-top computers. Preprogrammed with appropriate in-shop data, then fed the range and size characteristics of a particular photograph, the developer-activity status, and the specific interpretation desired, the computer executes about 800 calculations and, in seconds, delivers a printout with recommended main, flash, and bump exposures. As you might expect, the output is only as useful as the precision and thought behind the preprogramming and the validity of the subsequent input. With proper client direction and sensitive camerawork, the interpretation can be superb.

Prior to press you can obtain a preview of the interpretation by asking to see "blackprints," prints made by the lithographer from halftone films contact-printed on Kodak Rapid Paper or an equivalent material of another brand. The paper is processed in conventional lith developer just as the lithographer's films are, and produces a D/max approximating printing-ink density. The only variable not built into this proof is dot gain and, with a bit of experience, you should be able to predict its effect.

In addition, you should be invited to meet with your printer and "Monday morning quarterback" each job, at least until you are confident that the lithographer understands your style and goals, so that he can make an intelligent effort to achieve them. We have, at our plant, a "Museum Halftone," for example, and another style named after a well-known graphic designer for whom we work. Producing images for both clients is not difficult although the two styles require different techniques, because in each case the client has let us know what he wants.

A technique that produces a greater maximum ink density, and consequently a longer tonal range, than conventional printing is called duotone reproduction. Don't be misled by the term *duotone*; it is a misnomer. A duotone is not an image in two tones, nor is it necessarily one made from two halftones. It is simply an image made by a two-impression printing. Depending upon regional and shop differences and upon a designer's choice, a duotone may mean:

– A halftone image in one color printed over a solid panel in a second color;

– A halftone image in one color printed over a very high contrast line image in a second color;

– A halftone image in one color overprinted with the same plate in another color.

None of these renderings is normally as pleasing to the photographer as a fourth type, an image created by a duotone technique that employs two halftones made from the same original image, but with the local and total contrast altered a different predetermined amount for each. When these are overprinted in black and a color, the combined effect is one of increased density and range, in addition to a color quality that may be more compatible with the subject matter and design of the presentation in which it appears.

Even with this type of duotone – two halftones of differing tonal scale, overprinted – there is ample room for variety beyond the choice of ink colors. First, the separate scale and range of each halftone in the pair provides options among many degrees of color cast, from subtle to bold, and many varieties of contrast. Second, screen fineness for both halftones in the pair need not be the same.

An image with broad areas of flat tone requires a fine halftone screen to keep the dot pattern from becoming obvious and distracting. This is a 175-screen, elliptical-dot, double-black duotone. Photograph © 1983, Jerry Sarapochiello.

Printing one of the halftones with a finer screen can produce a duotone that eliminates the characteristic rosette dot pattern, a pattern that in flat tone areas can be obvious and distracting. Finally, one or both conventional-dot screens may be replaced with one that creates a mezzo or other special effect that will add interest to an otherwise ordinary photographic subject.

The most vivid and beautiful black & white reproductions available are made with the double-black duotone technique. To obtain maximum density and local contrast, two halftone plates of widely disparate range are made and both plates are printed with black or almost-black ink. Although the double-black duotone, well executed, may be the closest in fidelity to the original print, it presents an obvious design limitation. A client, budgeting for a two-color brochure, is often unwilling to resign himself to "...two colors, but both colors are black." Still, if the dynamic quality of the images is of major importance, this option should not be casually set aside.

In fact, then, there is no single definition for a duotone. There is, rather, an almost infinite variety of duotone renderings, and your printer should be able to show you an array of previously produced work from which to select a style that will most enhance the reproduction of your photographs or will be most appropriate for the presentation in which it appears.

Duotones are not limited to black and one specific second color, nor is the tonal scale in each film limited to one interpretation. The three duotones on these pages differ both in the choice of a second color and in curve shape.

Photograph © 1978, Lilo Raymond.

Photograph © 1971,
Lilo Raymond.

House in Florida, Paul
Rudolph, architect. Pho
tograph © 1971,
ESTO/ Ezra Stoller.

Double-black duotone.
Photograph © 1983,
T. W. Sanders.

Double-black duotone.
Photograph © 1954, W.
Eugene Smith / Black
Star.

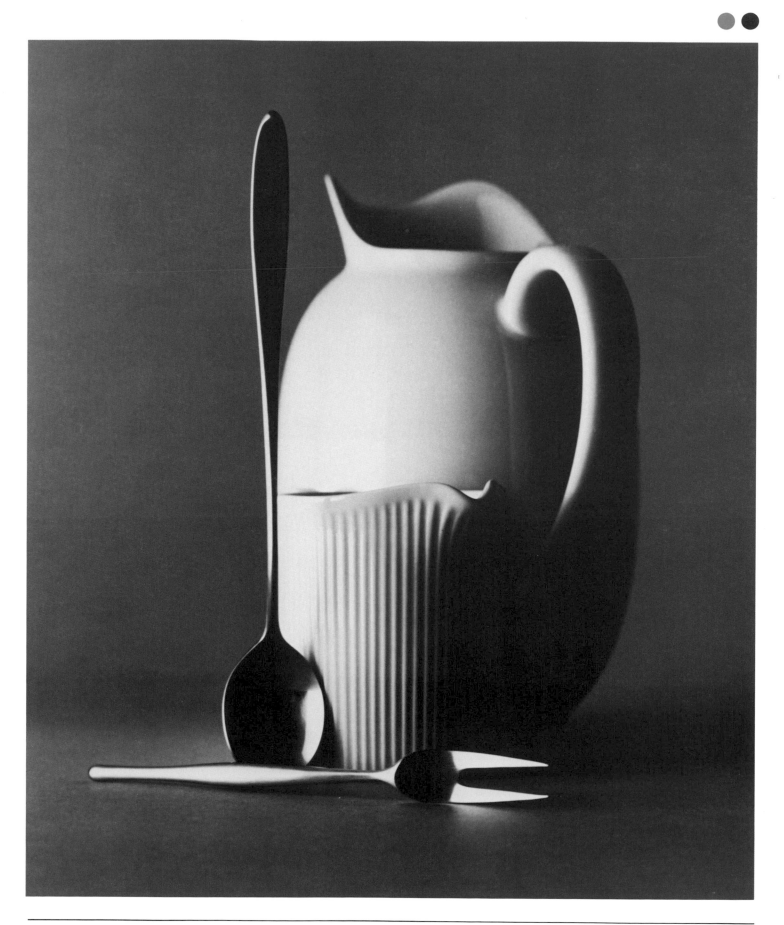

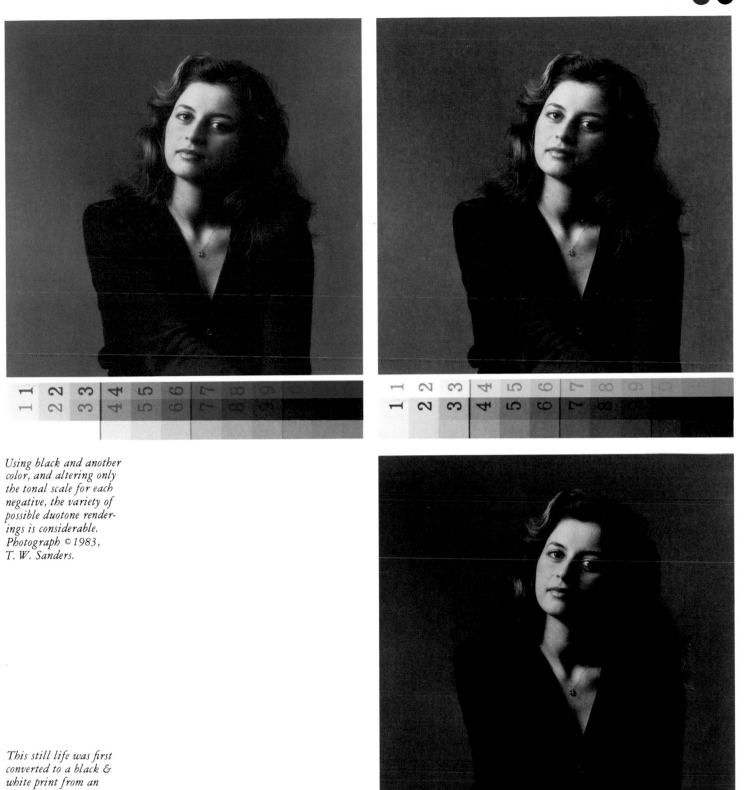

Using black and another
color, and altering only
the tonal scale for each
negative, the variety of
possible duotone render-
ings is considerable.
Photograph © 1983,
T. W. Sanders.

This still life was first
converted to a black &
white print from an
8 × 10 transparency.
This is a duotone
reproduction from the
black & white print, and
black ink was not used.
Photograph © 1975,
Henry Sandbank.

The double-black duotone technique, properly applied, provides the closest fidelity to the original print. Photograph © 1982, Peggy Barnett; courtesy of Irving Bank Corporation.

Conclusion

In conclusion, I want to remind you again that your commercial photograph, whose value is measured by thousands of lithographed reproductions rather than by a single original print, must be crafted with the lithographic process in mind. The lithographer needs a sharp image with a controlled density range, modeled tones, and both shadow and highlight detail. Such an image is not an accident; it means using the largest camera format and the slowest film practical in a given situation; it means keying a film's exposure index and development time to the luminance range of the scene, flare conditions, and the particular demand for shadow-tone separation. It means attention to sources of illumination; it means using a firm tripod; it means clean and patient darkroom procedures; it means selecting a proven type of print paper and properly spotting and mounting the print; and it means communicating with both your art director and the lithographer he has chosen. Consider all the details, and the printed reproductions of your photographs will never again seem to have been chewed up and spit out by the system.

Densitometry Refresher

Density is an easy-to-handle index of light in relation to transparent materials (negatives, transparencies, and filters) and reflectant materials (prints).

In reference to a filter, for example, the following terms apply:

Transmittance: A numerical designation for that part of light which passes through the filter. It is expressed as a percentage or as a fraction of the light directed at it. If half the light present passes through the filter, transmittance is 50 percent or ½.

Opacity: The inverse of transmittance; the transmittance fraction inverted. Transmittance of ½ is an opacity of 2/1 or 2, indicating that in order for 1 unit of light to be transmitted by this filter, it must be illuminated with 2 units of light.

Density: The opacity number expressed as a logarithm. Opacity of 2 = Density 0.3. Therefore, a neutral density filter designed to reduce light transmittance to the film by 1 stop (or 50 percent) is a 0.3 filter.

In reference to a photograph or a printed halftone, the same mathematics apply, but instead of transmittance, we deal with reflectance. For example, 18 percent reflectance indicates that a given tone reflects 18 percent of the light incident upon it. Expressed as a fraction, 18 percent is 1/5.556. That fraction inverted is 5.556, and the logarithm of 5.556 is 0.74. So, 18 percent reflectance is a density of 0.74.

Density Range: The difference between two measured densities. For example, a print with a highlight density of 0.10 and a shadow density of 1.90 has a density range of 1.80. (1.90 − 0.10 = 1.80).

The density measurement of a print is most precisely determined with a reflection densitometer, an electronic device too costly for most darkroom budgets. An inexpensive, practical substitute is a visual-match scale. Your print densities can be approximated by comparing them to the patches on a Kodak Reflection Density Guide (Q-16).

A more comprehensive guide to the practical use of density data in photography appears in my book, *Photographic Tone Control*, which was published by Morgan & Morgan.

Density value, rather than "percent reflectance," is the lithographer's tone reference. This inexpensive card is useful in identifying tone density and in calculating density range.

Color
Photographs
for
Reproduction

of panchromatic film to color art while using a different filter for each shot.

Halftone Screen:
A special kind of screen through which the cameraman exposes his high-contrast film to your photograph or to a CT in order to procure a black-and-clear film record in which the continuous tones of the image have been broken into various-sized dots.

What color separation is and how it is accomplished; Why the principal problems of color reproduction are tone reproduction, gray balance, and color correction; What the devices of separation are, how they compare, and in what ways the scanner is unique among them; How to preview color reproductions before the run: three types of proofing after separation.

Chapter 5

Color Separation and the Printing Process

A full-color reproduction of an individual picture is, in most cases, the result of imposing four separate halftone images in register on paper. One printing is in yellow ink, a second in magenta, a third in cyan, and the fourth in black.

Color separation into the cyan, magenta, and yellow printers is accomplished by photographing the color art successively through specific red, green, and blue filters as indicated in the schematic on page 65. The filter for the black printer is designated "xx" in the schematic to indicate that there are several approaches to creating this film record, ranging from split-filter techniques (partial exposure through each of the three filters separately) to the use of a single special filter.

In addition to color filtration, halftone screening is involved in creating the color printers. This procedure is necessary because lithographers can't create a tonal scale by depositing varying quantities of ink on different areas of the plate. Instead, we create an illusion of a tonal scale by using a halftone screen to break the picture into various-sized dots clustered more or less densely according to the tonal values in the image. The entire image area of the printing plate receives and transfers a uniform ink film, but varying clusters of printed dots on paper give the illusion of various tonal values in each of the four process colors.

The color separation and halftone screening allow us to reassemble the image on press in such a way that an enormous color gamut is available for the reproduction. From the close proximity of different-colored small dots that visually fuse and the overlapping of larger dots, we derive a vast range of subtly variegated color.

Methods of Color Separation

Two techniques for introducing the halftone screen are in use today for reproduction from both transparencies and color prints. Depending upon the method chosen, the process is referred to as *direct* or *indirect*.

Direct Color Separation. This photographic technique involves placing a filter at the lens of the graphic-arts camera and a halftone screen in front of the high-contrast panchromatic film at the camera back, thus accomplishing both color separation and screening in one operation. There are four sheets of film, four filters, and four exposures through the halftone screen to produce the four halftone color printers.

Indirect Color Separation. This technique divides the photographic process into three principal steps for each color printer. First, the filtration operation is performed; the art is color-separated onto continuous-tone panchromatic films, one for each of the four colors. These negatives—sometimes referred to as CTs—are then individually put up in the copy holder and photographed onto high-contrast film through a halftone screen. This second step produces screened positives. As a final step, contact film negatives are made from the screened positives, and these negatives are used in the platemaking.

It should be noted that the color-separation methods described here define the process only in basic terms. In practice, refinements are introduced and flaws are minimized through additional, intermediate photographic steps.

The direct color-separation method offers the obvious advantages of speed and economy. In addition, since fewer steps are involved in arriving at the final color printers, some people feel that the reproduced image can be sharper. On the other hand, indirect color separations (which produce a set of filtered continuous-tone negatives—CTs—prior to screening) have other assets. Among them is the potential for more delicate retouching on the CTs, when necessary, than can be accomplished on local areas of halftone films. Blemishes can be eliminated and other cosmetic improvements can be made on the CTs with a photographer's conventional film-retouching tools, and the evidence of this manipulation is camouflaged somewhat during the screening step. Halftone films, in comparison, are more difficult to alter, and fewer kinds of corrections are possible. In addition, with the indirect method, the lithographer can use one set of continuous-tone negatives screened to several sizes, should the job require it, rather than starting from scratch each time.

There is another significant advantage to the slower and more costly indirect method. Since the tonal-curve shape and range of each of the final four films must complement the others, with the entire set fitting within a standard, it is customary—regardless of separation method—to photograph the art with a three-aim-point scale alongside. (The aim-points denote the desired density in a specific highlight, midpoint, and shadow tone.) When employing the direct method of color separation, if the aim-points on the filtered-and-screened films are not properly recorded and the result is unacceptable, the filtering and screening must be repeated. The indirect method allows for reading of aim-point densities on the CTs, with the extra opportunity for adjustment during the screening operation for any desired density shifts. Simply put, the indirect method allows for more "steering" in making each of the printers, and this is a vital element in quality control.

You may be aware that the procedures followed in making CTs for indirect separations are not unlike those used in the more familiar dye-transfer process. But since the dyes in photographic color prints are different from printing-ink colors, different filters, aim-points, and curve shapes are employed. And while dye transfer is a three-color process, color separation provides for black in addition to the three colors. The primary purpose of the black printer, incidentally, is to extend the tonal scale and darken some colors, *not* to create an underlying image to which color will be added, as is often believed.

Which method—direct or indirect color separation—is better? There is no quick, easy answer that is right for all projects at all times. Among the elements that enter into the decision are the subject matter of the color art, the actual color-separation devices and materials used, the talent of the craftsmen, and—above all—plant standards.

I am going to digress briefly here to talk about aim-points, an expression I have used in this discussion without much explanation. The information is valuable in itself, and it will help clarify what I mean when I speak of printing-plant "standards," although monitoring aim-points is just one among many quality-control techniques.

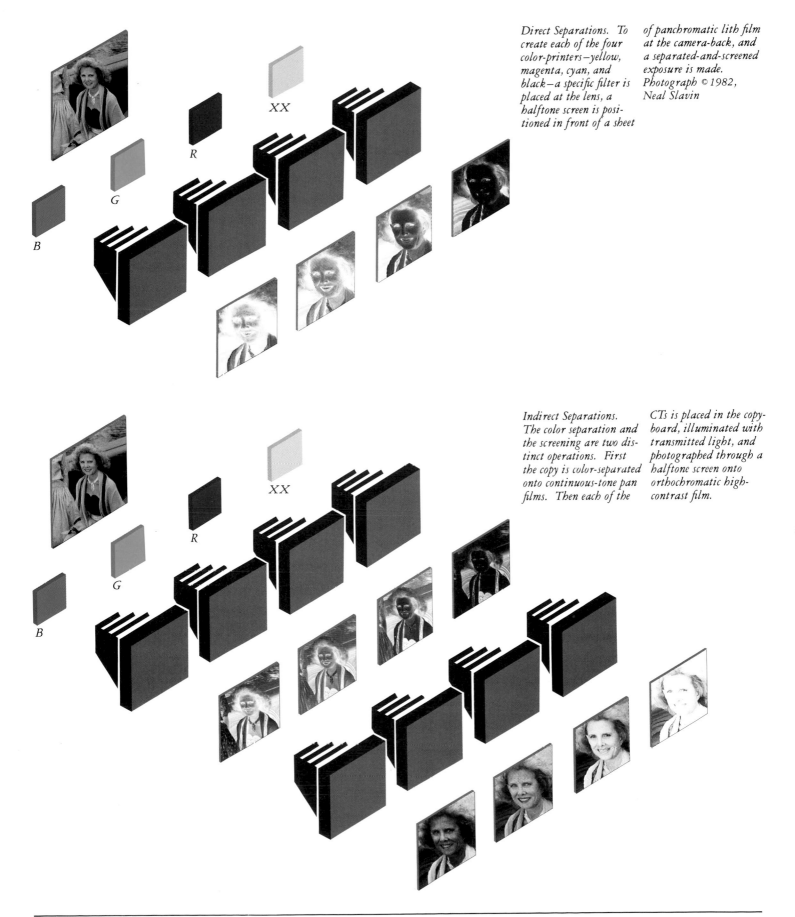

Direct Separations. To create each of the four color-printers—yellow, magenta, cyan, and black—a specific filter is placed at the lens, a halftone screen is positioned in front of a sheet of panchromatic lith film at the camera-back, and a separated-and-screened exposure is made. Photograph © 1982, Neal Slavin

Indirect Separations. The color separation and the screening are two distinct operations. First the copy is color-separated onto continuous-tone pan films. Then each of the CTs is placed in the copyboard, illuminated with transmitted light, and photographed through a halftone screen onto orthochromatic high-contrast film.

To a photographer, one aim-point is his mental measure of the appropriate shadow density in a negative that assures him the film has not been underexposed. I say mental measure because the photographer's comparison of aim-point to negative is judged by experience, rather than computed precisely with a transmission densitometer.

The same holds true for the comparison of a second aim-point to the film's highlight density. Here a photographer makes an evaluation of that part of the scale where film development time has the greatest effect. Depending upon these judgments, preliminary decisions regarding paper contrast grade and local dodging or burning-in may be made.

For a graphic-arts cameraman, however, both visual evaluation and the photographer's two-aim-point system are unreliable. Subtle differences in tone density or in dot size and the effects of eye fatigue make such judgments far too imprecise. Remember that, in lithography, if the density of the control patch does not come close

enough to the aim-point, there are no contrast grades of lithographic plate with which to compensate. That is one reason a transmission densitometer must be used. In addition, two aim-points—the intended highlight and shadow densities—provide range information only and reveal little about local contrast. In the illustration of the characteristic curve, drawn in the extreme for clarity, two hypothetical films have been plotted, both with identical range. They would meet the two-aim-point criterion, but the image difference would be considerable. Film B would have far less shadow-tone separation and more middletone and highlight contrast than film A. With a two-aim-point system, the emphatic difference—and the deficiencies in one of the images—would go undetected.

So lithographers, when photographing a color image, use three aim-points—highlight, midpoint, and shadow. A small three-patch scale is attached to each photograph before separation: a highlight patch, a midpoint patch of 0.7 density (a touch lighter than an 18 percent gray card), and a shadow

patch. Monitoring the densities of these patches on cameramen's negatives provides control of range and, in addition, control of local contrast unidentifiable in the two-aim-point system.

In essence then, to a lithographer the three aim-points are the specific density criteria for each of the preliminary and final halftone films of the set required for each image. But, as *The Dictionary of Contemporary Photography* notes, "...a real process never meets the aim exactly." So the determination of acceptable printers in either process, direct or indirect, depends upon the margin of deviation from the optimum—the aim-points on each film—considered tolerable by a given lithographic company.

Ultimately, it is the standards of each individual plant that determine the quality of its reproductions. In the last analysis, the choice between color-separation processes has less bearing on the quality of the printed image than the choice between lithographers. Beyond that, even within a chosen plant, there may be a range of standards imposed by considerations of time and cost.

The main concerns in color separation and the printing process can be classified into three groups: tone reproduction, gray balance, and color correction.

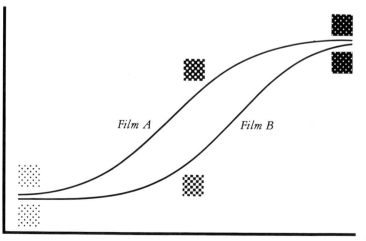

Comparing only the ends of these film density curves, one might conclude the films were alike throughout their scales. Monitoring a third aim-point at approximately mid-curve reveals a vast difference between them: Film B has far less shadow contrast and more middletone and highlight tone separation than film A. On the printed page, the images produced from these films would look markedly different.

Tone Reproduction

Tone reproduction refers to the color density on the printed sheet as measured against that on the color art. Since the density range of virtually all color-art media, particularly transparencies, exceeds the range of printing ink on paper, precise tone reproduction is impossible. The printed image cannot have the length of scale or the tone separation throughout its range apparent in the original. And it is these very elements of total contrast and local modeling that give an image its vitality—its "photographic quality." The problem lies in the need to compress the tonal range while sacrificing as little as possible of the character and integrity of the original image.

Lithographers have learned that the most obvious solution—equal reduction of tonal differences throughout the scale (the way one might squeeze an accordion so that it occupies less space) usually produces an unaesthetic result. Although the technical need of range compression is served, the subjective qualities that affect viewer perception are not. Nor are these qualities served by attempting a tone-for-tone match part way through the scale, with the excess lopped off and reproduced as featureless black or pure white.

Instead, since the eye is usually drawn first to the highlight end of the tonal scale, the most aesthetic result is obtained by favoring the highlights through the upper middletones and increasing the compression from there through the shadows. With a three-aim-point guide, this objective can be precisely monitored. As a rule, fidelity to an original and maintenance of "photographic quality" begins, and largely rests, in the lighter half of the tonal scale. There are, of course, exceptions to this rule. After all, we're not reproducing simply a scale of tones, but a vital and compelling visual image.

A lithographer, like a photographer, produces a rendering, *not* a duplicate. And like a photographer, he deals with variables that must be balanced against each other. That is why it is necessary for you to do more than just hand over your images to him. The pictures should be discussed in terms of subject emphasis and drama. The lithographer interprets that information to determine total curve shape and local contrast and to decide where the scale can best afford compression.

Tone-scale reproduction is important; it is flexible; and it requires your direction before the separations are made, not some desperate salvage technique after you've seen the proofs.

Gray Balance

Assuming that the neutral grays in the original should be reproduced as neutrals, the lithographer's objective is to create that effect with three or more colors. Unfortunately, even under the best of production conditions, equal quantities of the three process colors (yellow, magenta, and cyan) do not produce gray, but brown instead. This problem is caused for the most part by the color contamination of printing inks induced by imperfect pigments and such additives as varnishes and drying compounds. To some extent the balance is further distorted by the surface and absorption characteristics of the paper, and by press conditions.

In order to achieve the subtle balance of colors required for neutrals, the contrast curves of the four color printers, rather than being identical, must be modified so that each will print a controlled quantity of a specific color. This kind of programming places considerable demands on presswork as well as camerawork.

To realize the delicacy of monitoring the presswork, consider that the average ink film is one micron (one twenty-five thousandth of an inch) thick and that a deviation of only half a micron is enough to reduce quality.

Gray balance is, in a way, color balance as well. And since lithographers work with it daily, they can be of assistance when out-of-balance transparencies (too pink or too green) must be used. Although the precise corrective technique employed during color separation is beyond the scope of this discussion, full descriptions are available in the literature cited at the end of this book. A more practical consideration—how to communicate to your lithographer the color-balance shift you desire, away from art—will be discussed a little later.

Color Correction

Ink deficiencies, which we have seen as the cause of limited density range in lithographic reproduction and which rule out the possibility of identical-curve-shape separations to create a gray balance, are again to blame for our inability to duplicate the precise purity and saturation of colors.

As you know, white light consists of approximately equal quantities of the primary colors, red (R), green (G), and blue (B). Each primary printing-ink color is designed to reflect two of those and to absorb the third. Bear in mind that it is only the reflected color that we see. This is what happens when an ink color is illuminated with white (R + G + B) light:

Ink Color	Reflects	Absorbs
Cyan	Green, Blue	Red
Magenta	Red, Blue	Green
Yellow	Red, Green	Blue

Remember that an overprint of two transparent ink colors allows only a single color—common to both—to be reflected when illuminated with "white" light. That's why equal quantities of cyan (which reflects green and blue) and yellow (which reflects green and red) produce green, and why magenta (reflecting R + B) and yellow (reflecting R + G) produce red, and cyan (reflecting B + G) and magenta (reflecting R + B) produce blue.

Unfortunately printing-ink colors are imperfect—each reflects a portion of the color it should absorb, and this reduces the purity of the final color. The condition is called "color contamination." Although yellow is almost pure, cyan ink—the most color contaminated—acts as though it had some magenta and yellow mixed in with it, and magenta acts as though it had some yellow and cyan mixed in. The result is both a shift in the reproduced color and a desaturation of

it: clean greens go olive, and gouda-cheese-wrapper reds become orange. And, since the amount of color contamination is not the same in all three, equal quantities of yellow, magenta, and cyan do not produce tones of gray.

The lithographer begins with three reproduction handicaps: a shortened tonal scale, a tendency to lose tonal differentiation in the shadows (the area of greatest tonal compression), and impure ink colors.

The most widely used way to minimize the effect of these handicaps is a technique called masking.

A mask used in color separation photography is like a Halloween mask, an image placed on another image to disguise it, to change the way it looks. In photography, a mask may be made by photographing the

The primary colors of "white" light are Red (R), Green (G), and Blue (B).

White paper reflects the R + G + B light.

R + G light reflection, visually blended, appears Yellow.

color art, say a transparency, through a special filter. The result, a film *negative*, may then be attached to the chrome (a *positive*) in register, to change the appearance of the image. Specifically, the mask will compress the tonal scale and, because a filter was used to create it, will alter the density in some colors more than in others. The pair—chrome and mask stacked together in register—then becomes "camera copy" for the separation procedure.

In essence we are adding a mask to disguise the color art and compress the range so that when we reproduce the altered scale with low-density, color-contaminated ink, we come closer to the original in feeling, if not in fact.

In using a mask we are not limited to attaching it to the transparency. For technical reasons, masks may also be attached to the continuous-tone films (CTs) or placed at the camera back in front of the unexposed film prior to the separation or screening procedure.

Among other things, these alternative techniques make it possible to mask opaque copy as well as transparencies.

Selecting the precise mask filter and film and computing the density range and local contrast of each mask is a highly sophisticated task. It takes into account dye sets in the transparency, spectral-sensitivity and photographic-response curves of mask film and of separation film, curve segment and degree of range compression required, spectral distribution of the illuminant, ink color contamination, and a host of other factors.

These computations have been meticulously worked out in the industry, and instructions for their practical application are readily available. The lithographer's primary task, after modifying the program in accordance with his in-plant test results, is to use the data with precision. Even so, the color gamut available in dyes far exceeds that of ink pigment. That fact, in addition to the ink color contamination, the shorter range obtainable, the shadow-

contrast compression and the halftone screen's effect on sharpness, is one more reason that the frequent order to "match art" cannot be filled.

Masks are used in both direct and indirect separations. While it is reasonable to assume that only a single mask is required for each color, the practice of masking is neither so limited nor so simple. It is not unusual to require as many as 16 or more balanced films (and the monitoring of 48 aim-points!) before making press plates for a single image.

I have so far outlined the methods of both direct and indirect color separation and the components of technical quality—tone reproduction, gray balance, and color correction. As the final segment on mechanics, I want to familiarize you with the most common devices of contemporary color separation.

R + B light reflection,
visually blended, appears
Magenta.

G + B light reflection,
visually blended, appears
Cyan.

Black ink absorbs the
R + G + B light.

Color-Separation Devices

Any one of four different devices may be used in the film-exposure phase of color separation, each of them capable of doing a first-rate job.

Graphic-Arts Camera. The schematics of the color-separation process (page 65) show the use of one of the four—a camera—in making the various continuous-tone and halftone films from which the lithographic plates derive. The cameraman places color prints and other opaque copy in the copyboard and illuminates them so that light is reflected from the art as in conventional photography. When the color art is in the form of transparencies, the copyboard, which has a translucent rear surface, is back lit so that the copy can be photographed with transmitted light.

Often, however, color separations are made without a camera, using instead a contact frame, or an enlarger, or a scanner.

Vacuum Contact Frame. Contact separations require a vacuum contact frame and a special light-source housing. Incorporated into this housing, between the light source and the frame, is a wheel on which are mounted a series of color-separation and mask filters. The appropriate filter is selected by simply rotating the wheel (usually electrically) to place a given filter in the light path.

Among the advantages of a contact system is that, because no lens is involved, the aberrations introduced by lens idiosyncrasies are avoided. Another advantage is that, since the position of the photographic apparatus is fixed, exposure is more consistent than with a camera system where copyboard and lens are subject to repositioning as reproduction size is changed. In addition, the contact system lends itself best to the economical practice of making color separations in clusters rather than singly.

For group separations, a professional color lab first makes duplicate transparencies (or chromes from opaque art) to the reproduction size of the images. These are then assembled in the design format, and the group is color separated as a single entity. This method presents economies on two levels. First, several images may be separated at one time, usually at a saving that significantly exceeds the duplicating and assembly costs at the lab. And second, the assembly of the duplicate chromes greatly simplifies and speeds the positioning of the multiple images on the lithographer's flat in the stripping operation. Nine chromes designed to appear in a tic-tac-toe cluster, for example, would be duped to reproduction size and assembled by the lab, then sent to the lithographer to be separated and stripped as one, for as much as an 80 percent reduction in separating and stripping time. When duplicate chromes intended for gang separation are made, however, certain criteria must be met in order to maintain a consistent quality of reproduction. I'll talk about those later on.

Enlarger. The enlarger is also a very popular color-separation device. It offers the opportunity for considerable image enlargement—usually far beyond the capability of a process camera—and because of its size and vertical design, occupies less space and may be operated more efficiently than the camera.

Sometimes a combination of devices is used in making separations. For example, masks may be created in contact, and separation and screening (along with size change) may be accomplished in the camera or enlarger.

The Process Camera. Behind an opaque pad in the copyboard is opal glass. Removing the pad and repositioning the lights behind the copyboard allows the cameraman to place transparent copy—such as CTs and transparencies—on the glass and photograph it with transmitted light. The door at the camera back is a vacuum film holder. It accommodates a variety of film sizes. Placement of the copyboard and lensboard in relation to the film determines the size of the reproduced image.

Scanner. The fourth method of separation—by color scanner—is the most sophisticated and demonstrates the application of computer technology in the graphic arts. This film-exposing device is capable of making the separations quickly, efficiently, and with great opportunity for operator-directed modification of its output.

Available scanners offer various combinations of performance capabilities. A particular scanner may do some or all of the following:

— Accept color art in the form of transparencies, color negatives, or unmounted color prints (not for separation together, however);

— Produce a film negative or a film positive;

— Produce a laterally reversed image when desired;

— Provide a choice of continuous-tone or screened films;

— Expose for as many as all four plate-ready separations in one pass;

— Offer an image reduction and magnification capability of approximately 20 percent to 3000 percent;

— Produce color separations to a size of 44 × 50 inches.

Unlike a process camera, enlarger, or contact device, the scanner does not read and expose for the total image at one time. Instead, it scans an image that is revolving on a horizontal drum as you might imagine a cylindrical phonograph record would revolve while playing. The visual information it receives feeds into a computer that has been preprogrammed to edit the data according to what is desired in the separations.

There are several advantages to using this device. One of the most obvious

is the economy of material and time. Since the separation, masking, and screening are computer-combined, the scanner can expose for a set of plate-ready films in one uncannily swift operation. Four pieces of film are used instead of the sixteen or more common in indirect camera separations, and the entire process may be

completed in about twenty minutes, although technical considerations sometimes call for a little more time than that.

Modifying the original proportions of an image in order to solve a design problem or create a dramatic image distortion is accomplished easily by a scanner.

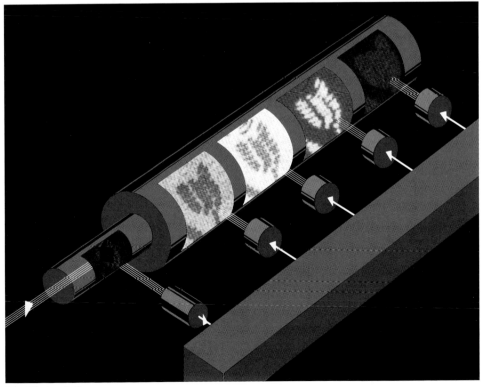

The Electronic Scanner.

In addition, there are controls on the scanner that allow the operator to make such "editorial changes" as modifying color balance and local contrast or altering the saturation of a particular color. He may even alter the edge contrast of objects in the illustration to increase apparent image sharpness.

One of the most useful options in a color scanner is the control of the precise height of the reproduced image, independent of its width. If the revolution rate of the exposing drum is modified to alter the ratio of its speed to that of the lateral movement of the exposing lights, a 35mm transparency can even be produced as a square image! I don't recommend this for photographs of such objects as bicycle wheels or eggs, but there are occasions when this unique scanner option—judiciously used—can be a tremendous help.

Suppose, for example, that you have a 35mm transparency that you want enlarged to 8½ × 11 without sacrificing any pictorial information that is in the original. The 2:3 format ratio of the chrome would normally enlarge to about 7¼ × 11 (too narrow), or 8½ × 12¾ (too long). In this case, an adjustment of the scanner control would provide the 8½ × 11 image with no loss of image information.

There is some distortion, but in many cases this is imperceptible. The scanner may also be programmed to repeat a data-scan and, in doing so, extend a sky or seamless background to better accommodate a specific page design.

On some scanner models, the film-exposing light is a laser, a type of illumination that offers increased control over highlight and middletone realignment. The laser scanner is superb for maintaining and even enhancing image sharpness and the dimensional quality of textures in the upper half of the tonal range. In my opinion, however, it does not provide the shadow tone control available with a conventional scanner. Therefore, when the original image has an ultralong range and important shadow detail, separations are better trusted to a conventional scanner than to a laser model.

Proofing After Separation

Once the separations are made, it is customary to preview the color rendering of the images before the production run. Currently there are three types of preview in general use—the overlay proof, the laminate proof, and the press proof.

The Overlay Proof. The overlay proof is the simplest type of preview to produce. It requires a set of four light-sensitive transparent sheets, each carrying a different color-dye emulsion—yellow, magenta, cyan, or black. Each of them is exposed through its appropriate separation halftone film and developed. Then the separate overlays are superimposed in register and taped to paper. The result is a full-color preview of the reproduction. The process is economical, fast (all four sheets may be exposed side by side in a contact frame), and versatile. If, for example, the image is ultimately to be reproduced on colored paper, the set of overlays may be taped to a sample of the actual production stock.

A transparent color overlay proof.

But overlay proofs have their limitations, not the least of which is the color cast imparted by the unprinted areas of the transparent overlay material itself. It is not colorless and often adds an amber or gray tinge to the image. In addition, the dyes do not have the intensity of ink pigment and may also be at variance with production inks in value (tone) and chroma (purity). Although only a technician experienced in comparing proofs with subsequent press runs can consistently use them as a reliable preview, overlay proofs are a very useful general guide.

The Laminate Proof. For the laminate proof, a transparent, light-sensitive sheet is laminated to paper, then exposed to one of the halftone separation films. The appropriate color may be introduced during development, or it may be present in the emulsion from the start. After development, a second sheet is laminated over the first, then exposed and developed. The process—laminate, expose, and develop—is repeated with all four colors. This procedure takes

longer than overlay proofing and is more expensive, but the result is a superior guide for determining whether further work is needed on the separation films before platemaking and printing. Unfortunately, with this kind of proof, the very lightest tones in a picture are often less accurately recorded than the rest of the scale, and there is a slight overall color cast created by the thin, transparent laminate material. Moreover, slight variations in method, in materials, or in both may produce inconsistent and misleading results. Still, the laminate proof provides a useful, practical preview of the production run, one that can be significantly better than the overlay proof.

The Press Proof. By far the most accurate (and, alas, the most expensive) preview is the press proof. It is precisely what the name implies, a sample from a short preproduction run on a lithographic press. There are three kinds of press proof: the *float proof* (sometimes called a scatter proof

or random proof), for which all the images of a given project are placed on a press sheet without regard to their order or position on the production press sheet; the *in-line proof*, on which images are assembled in an order that approximates that of the production run to show the effect of the ink distribution on the different images; and the *in-position proof*, on which all the images appear in the precise position they will occupy in the production run. Understandably, the last is the most accurate of the three types of press proof. As more components of the proofing are matched to those of the press run, fidelity of proof to production press sheet is increased. The most valid proofing involves using, among other things, the same plate brand; the same paper brand, weight, surface, and color; the same ink formula and sequence of colors; and the same press and press speed as for the production run.

With each element added to simulate production conditions, the cost of the proof increases, more for some factors than for others. But with any type of

A press proof, or prog, consists of the building-blocks of the full color image. Separate press sheets are produced from each of the four printers alone and in combina- *tion with the others. The prog serves as a guide when modifying the films from which revised plates will be made, and as a reference at the press dur-ing the production run.* *Not illustrated are spe-cial control guides that also appear on the prog. They are of concern only to the printer, and indi-cate the density of the four ink colors, how well* *they adhere one-on-another (a phenomenon called "ink trap"), and the degree of dot distor-tion caused by press pressures. Photograph © 1982, Neal Slavin*

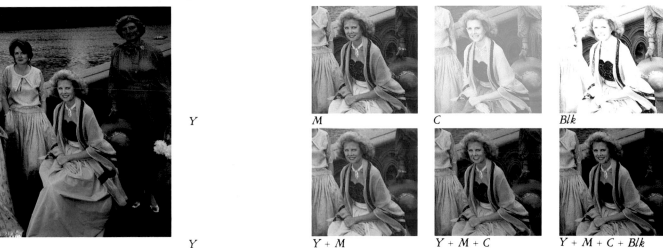

Y

Y

M

Y + M

C

Y + M + C

Blk

Y + M + C + Blk

press proof, transparent overlays tinged with amber are avoided, and the often critical element of dot gain—impossible to simulate off-press—is accounted for. In addition, when a press proof is run, sheets of the separate process-color images and their combinations are run as well. Collectively these sheets are called a progressive proof, or prog. The prog is of inestimable value as a guide for altering values on the separation halftone films before the production run and as a point of comparison when solving problems during the run. Even with the most diligent monitoring of paper supplies, ink batches, and production conditions, and with the most heroic efforts to keep each of these factors consistent throughout the run, minor variations present themselves. A perfect match of press proof to finished piece can never be guaranteed, but in a plant where fastidious monitoring is the rule, the deviations are minimized.

Other previewing methods are available, some of which include the use of TV monitors. One of the newest systems will seem to photographers to be the most obvious. The proof is made by exposing color-print photographic paper sequentially through each of the halftone separation films and its appropriate color-producing filter set. Exposures are timed to produce densities comparable to those of a typical press sheet. The final color print is far more economical than a press proof and costs even less than the laminate proof. The method has unquestioned promise. However, while it has been field tested, its use in printing plants is not extensive enough for an accurate assessment of its value.

In the last analysis, it is not simply the use of a particular color separation device, proofing method, or press that guarantees superb reproduction. It is, rather, the integration of many factors reflecting the lithographer's effort, experience, and standards. These include the validity of the input data, the meticulous programming of the total separation sequence, the sensitivity and skill of the technician in choosing between innumerable options, the strict monitoring and control of halftone film development and assembly, platemaking, proofing, and production run, and the maintenance of narrow aim-point parameters throughout.

And it depends upon one thing more: excellent copy to start with.

How to tell if a photograph will stand up to the effects of the printing process: checking for modeled forms in centers of interest, highlight and shadow detail, very sharp focus, controlled density range, and balanced color.

Chapter 6

Standards for Images in Color

What is "excellent copy to start with?" Repeated comparison of original art with its reproduction, in sheer volume and variety, provides an alert lithographer with a reservoir of data. Distilled, these data become practical guidelines for evaluating the reproduction potential of both black & white and color art. In reproducing black & white prints at our plant, we have found that four interrelated qualities— moderate total contrast, tonal modeling, highlight and shadow detail, and image sharpness—are vital. When dealing with color, similar standards apply, and the list is extended to include color balance.

Let's define these five characteristics as they relate to color photography, and then explore how your choice of equipment, materials, and technique can best serve your needs without cramping your photographic style.

An informal national survey of color separators indicates that an overwhelming proportion of the color art submitted for separation today— perhaps 85 or 90 percent—is on transparency material. For that reason, I will refer to transparencies more frequently than to prints. I will, however, discuss color prints where their unique properties warrant comment.

Moderate Total Image Contrast.
The ratio of highlight-to-shadow light transmission through a transparency may be as much as or more than 500:1. (In densitometric terms this is a range of 2.7 or greater.) Built into this enormous span is the potential for extreme contrast, the kind obtained when photographing outdoors on a brilliantly sunny day. On the other hand, the light-to-dark ratio of a four-color-process image on gloss-coated paper is on the order of 100:1 (a density range of 2.0), *one fifth the range of the transparency*; the range is even shorter if the paper is not gloss-coated. Therefore a high-contrast chrome is the least desirable color art for publication because it suffers the greatest tonal compression, the greatest compromise and manipulation of the tone curve "away from art" in reproduction. Moderate total image contrast should be your goal; it requires less compression and so provides greater fidelity of tone and color saturation in reproduction.

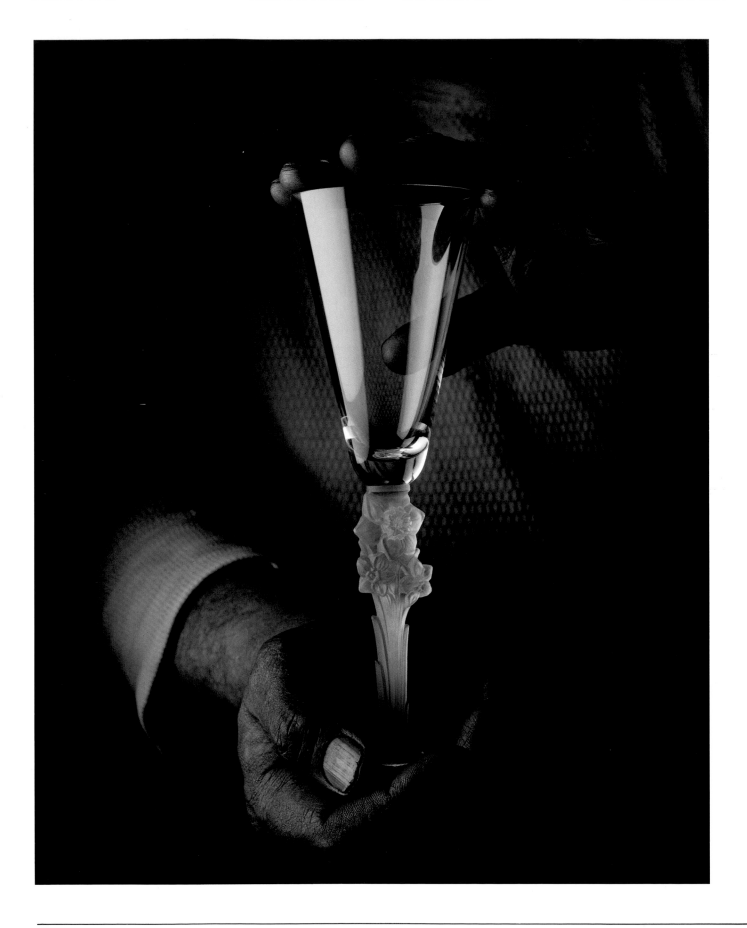

Local Contrast for Modeling. The shortened range obtainable in lithographic reproduction is often seen as a flatness in the reproduced color image, described as a loss of vitality, or dimension, or snap. If you were to photograph a scene that from the start was desaturated or monotonous in color (like a white-walled room of monotone computer cabinets lit by banks of fluorescent ceiling lights), your chrome might very well *still* convey a sense of the life of the room, because the color and luminance of the transparency create a kind of heightened reality. But with the special luminance of the transparency lost and the local contrast diminished in the reproduction, the image would die. This is, of course, an extreme example, but it illustrates the importance of providing enough crosslight to present texture, a variety of tones and colors, and an illusion of depth. Creating or increasing local shading in the scene with proper lighting is important for a vivid subject just as it is for a dull one, because tonal modeling—local contrast—is usually reduced in the printed reproduction.

Highlight and Shadow Detail. The sense of quality in a photograph, and subsequently in its reproduction, often originates in the detail revealed in the highlight half of the scale, the parts of the image usually seen first.

That is one reason this important portion of the transparency is compressed less in the tone-reproduction curve than are the lower middletones and shadows. Excellent chromes have easily discernible highlight detail; run-of-the-mill transparencies usually don't. In addition, we've noticed an important fringe benefit of highlight detail: transparencies that have it usually have excellent color saturation also; those with burned-out highlights are often thin in color throughout the scale, presenting poor copy for color separation.

Shadow detail, while usually not as important, gives the darker end of the scale a sense of contour, rather than a sense of heavy, uninformative mass.

Certainly, there are exceptions to these highlight- and shadow-detail criteria; let your aesthetic intuition enter into your evaluation. But more often than not, the need for detail at the extremes of the range is considerable.

Very Sharp Focus. Both black & white and color prints are almost invariably made oversized and reduced in reproduction. That makes sense. For one thing, dodging, burning in, and retouching are more easily done on an enlarged print. For another, image focus and general sharpness are easier to judge. Transparencies, on the other hand, are usually submitted smaller than final printed size and, if the image is compelling, the discovery that it is not in sharp focus is often made too late in the production sequence.

Certain scanner adjustments can at times help decrease the fuzziness of out-of-focus art, but try not to rely on this salvage technique. If the image is not razor sharp, it is best not to use it. Such art reproduces with an even greater loss of dimension and modeling. In addition, the halftone-screen pattern in out-of-focus areas of a reproduction becomes more apparent; the viewer's attention is drawn away from image content, and the purpose of the picture is obscured. Though easy to recognize when you look for it through a magnifier that enlarges the image to its approximate reproduction size, lack of image sharpness is the most common deficiency in color transparencies.

The original art was a long-range 8 × 10 transparency. The problem in reproducing this superb photograph was to maintain the subtle modeling in the glass sculpture— the upper middletone range. A scanner, which can be programmed to accomplish this kind of delicate interpretation far better than a process camera, was chosen for the separation. A conventional rather than laser scanner was used in order to preserve important shadow detail. Photograph © 1979, Phil Marco Productions, Inc. All rights reserved.

Color Balance. Color balance may be defined as the color fidelity of the image to our mental picture of the thing photographed. The words *mental picture* are important here because our evaluation of color fidelity is heavily weighted by our idea of how a given object *should* look. That weight is certainly most evident when we evaluate color in pictures that include familiar objects and familiar reference colors: flesh tones, food, and objects considered neutral gray (pavement, for example). As you know, the color of all light-reflecting objects varies greatly, depending on their environment and the spectral quality and intensity of the light source illuminating them. Still, we think we know how these objects "always look," surely how they're supposed to look, and in a transparency anything at variance with our mental picture is considered "out of balance." Determination of acceptable color balance, then, must reflect the subtleties of individual perception and taste, factors that are keyed to place, time, and personal history.

For successful reproduction of this image we had to create the illusion of tremendous range. We were able to solve the problem by modifying dot size in the screening process in order to print an enormous amount of each of the four colors in the background (the maximum amount of ink the paper would accept without smearing onto other sheets or splitting the paper surface), and "knocking out the spectrals"—allowing the white paper to show through without any halftone dots at all in the highest highlights. Photograph © 1983, John Paul Endress.

How to satisfy the criteria for color photographs: obtaining a sharp image, controlling contrast, increasing highlight and shadow detail, and controlling color; How to evaluate color images: the viewing environment; How to select the right color art medium for a specific job: transparencies vs. prints; How to avoid costly image mishaps.

Chapter 7

Meeting the Highest Standards of Color Art

We all know there are times when simply getting the shot must be your sole consideration—when a blurred or imperfectly exposed image is better than no image at all. But in the course of your commercial work such occasions are rare; generally there is time for foresight and for fastidious attention to detail during exposure, time to think about technical excellence as well as subject appeal.

There can be no argument against the photographic qualities I have outlined; they are the attributes every conscientious photographer wants in his work. However, whether those standards are adequately met is often a matter of judgment, and that judgment is what I am trying to persuade you to refine. You must develop a critical and intolerant eye, a heightened perception of the flaws that are minimized while bathed in the luminous color of your transparency only to show up disastrously in the lithographic reproduction.

On the following pages I will again draw your attention to these indispensable qualities while offering specific recommendations in regard to the equipment and materials you use and to your photographic approach as well. I expect you to resist, if not recoil from, some of my statements. After all, you have entrenched concepts of your own that will die hard. Nevertheless, I'd like you to take note of my opinions simply because, as a lithographer, I am probably involved with more photographs and their reproduction in a single year than you have to cope with in a professional lifetime. Ultimately you may see the logic of my suggestions and replace your present methods with new ones that will increase your effectiveness without jeopardizing your style.

The normal-range Koda-chrome transparency from which the separa-tions were made consists of reds, oranges, and pinks so pure in color and light in tone that the black printer barely con-tributed to this reproduction. Interior designer: Shattuck Blair Associates.
Photograph © 1983, Keith Scott Morton.

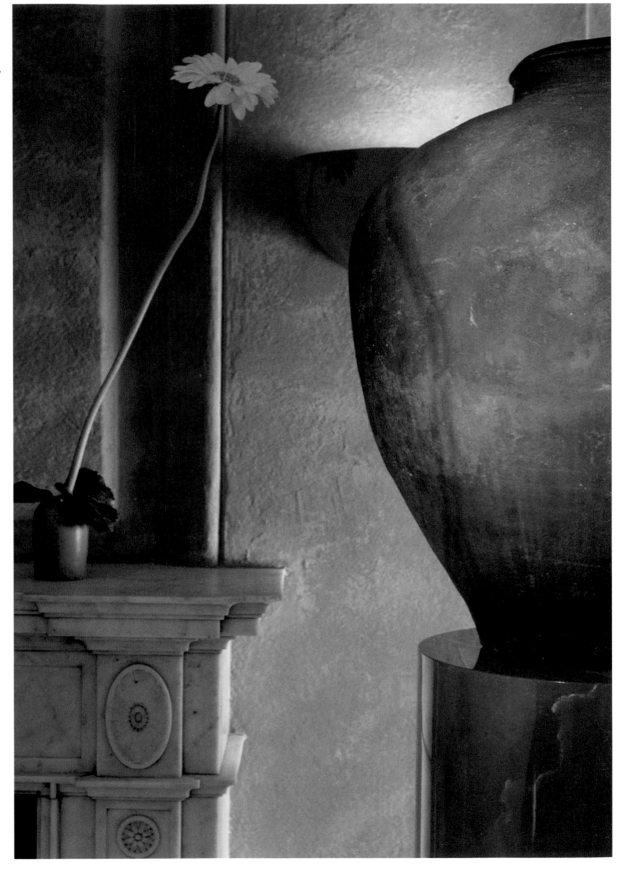

Obtaining a Sharp Image

From the thousands of transparencies we separate and print each year, we have learned that image sharpness is most often lost because of inordinate enlargement in reproduction, or camera movement (yours, not ours), or both. At first glance "inordinate enlargement" of your chromes seems a fault in design and not your province. But you cannot vindicate yourself so easily. A photograph is part of the solution to a communications problem and must maintain its visual integrity in whatever size serves that purpose best. For that reason it makes sense to use the largest practical film format rather than the most convenient one. The largest transparency provides the art director with the greatest flexibility in design, and the color separator with image sharpness least apt to be compromised in reproduction. The "largest transparency" is, of course, the 8 × 10 or 4 × 5 made with a view camera.

Admittedly view cameras, which are cumbersome and slow to operate, are impractical, if not impossible, to use in some shooting situations. But avoid rationalizing away their use entirely just for the personal convenience of a small, easily manipulated camera. You may also be giving away the crisp reproduction of your work and replacing it with a grainy image that lacks modeling and dimension. If, because of priorities determined at the shooting, a small- or medium-format camera is the most intelligent choice, examine the resulting transparencies through a magnifier that enlarges the image at least as many times as you expect it

	9"	12"	18"	24"
35mm short dimension	10×	13×	19×	26×
35mm long dimension	7×	9×	13×	17×
2¼" square	5×	6×	9×	12×
4" × 5" short dimension	3×	4×	5×	7×
4" × 5" long dimension	2×	3×	4×	5×
8" × 10" short dimension	2×	2×	3×	3×
8" × 10" long dimension	1×	2×	2×	3×

will be enlarged in reproduction. The accompanying table is a rough guide to full-image enlargement. A cropped image requires even greater enlargement.

In spite of these realistic magnification figures, a common practice is to judge the sharpness of 35mm chromes while viewing them through magnifiers that enlarge the image only four times. At the risk of sounding overly insistent, I want to emphasize the importance of scrutiny under sufficient magnification, because at present roughly 90 percent of the transparencies a printer receives for reproduction are 2¼ or 35mm.

To repeat: All things being equal, the rule of "the bigger the better" holds true for transparencies where image sharpness is the goal.

I realize that all things are rarely equal. For example, Kodachrome, which is available only in 35mm, has a warmth and general color quality that make many photographers prefer it, even at a sacrifice, to larger-format films such as Ektachrome. Actually, both Ektachrome and Kodachrome are equally suited for color separation, and the choice of one film over the other is more an aesthetic judgment of the photographer and art director than a technical one. When the overriding element to be considered is enlargement, it is inappropriate to use 35mm simply for the beauty of Kodachrome color. On the other hand, there are times when the color qualities of Kodachrome may outweigh the disadvantages of the 35mm size. Be aware, if you can, of the intended image size on the printed page. Then *consciously* make a decision regarding color vs. sharpness and dimension. It is your awareness of the trade-off that is really important.

Realizing that inordinate enlargement produces a soft, grainy image, photographers sometimes try to rationalize the use of a preferred film by comparing the resolving power and diffuse RMS (root-mean-square) granularity values of one film against another. This effort is based on the assumption that the comparison is a valid basis for film choice. And certainly high resolving power with low graininess gets you off to a good start. This is how five familiar daylight films compare:

Films	Resolving Power Classification	Diffuse RMS Granularity Value	Graininess Classification
Kodachrome 25	High	9	Extremely fine
Kodachrome 64	High	10	Extremely fine
Ektachrome 64	High	12	Very fine
Ektachrome 200	High	13	Very fine
Ektachrome 400	Medium	17	Fine

35mm Kodachrome is beautiful. But its dyes are capable of producing reds or oranges far beyond the printing-ink color gamut. In this case, after the separations were made, considerable additional "hand work"—local etching to change the size of dots in the films—was necessary to maintain the integrity of the original image. Dot sizes were altered to allow the pressman to run more than the normal amount of ink and increase the color intensity of the saturated reds and oranges without making the palette of lighter warm values flood and go muddy. Photograph © 1983, Jay Maisel.

Controlling Contrast

On the basis of these data alone, the Kodachrome with the fringe benefit of more dynamic color, appears to be best. In practice, however, these differences between the films are only part of an equation that *must* include magnification in reproduction. And since very often you cannot know in advance what the reproduction size will be, I recommend as large a size of film as shooting conditions permit. Using a format larger than 35mm means using the medium speed film, Ektachrome 64, even though it rates slightly lower in graininess than Kodachrome. Simply stated: If you're shooting transparencies for publication and reproduction size is uncertain, large-format "anything" is better than small-format "anything else."

In addition, I urge you to overcome a natural resistance to using an important accessory, a tripod. Use it whenever possible. Despite the popular notion that, by using a shutter speed computed upon twice the focal length of the lens, you can eliminate the effect of camera movement during a hand-held exposure (a rule that definitely limits your depth-of-field options and offers no real guarantee of sharpness), it is virtually impossible to hand-hold a camera and make consistently sharp nonflash photographs.

We often see the work of photographers who bracket their exposures ad infinitum but don't have the "time" to use a tripod. Almost invariably, the one transparency in a hand-held bracketed set that is best in sharpness happens to be the same one that is worst in exposure. Since blurring due to camera movement is magnified along with size in reproduction, you must make every effort to avoid it. Use a sturdy tripod and a cable release. In addition, prerelease the mirror, if possible, on single-lens reflex equipment.

Ironically, the camera that requires the firmest support because the image undergoes the greatest enlargement—the 35mm—is the camera least apt to be put on a tripod. The reason most often given is that a tripod impinges on a photographer's style. That may be true. It may not. Study the transparencies you've shot during the past month and see which of those that were hand-held exposures could have been made from a tripod without sacrificing style. Notice also how many could have been made with a larger-format camera. The analysis may shock you.

You will find, too, that a tripod-mounted camera provides increased opportunity to consider composition, focus, and depth of field. Usually, the presence of an unwavering image in the finder promotes work less in need of "salvage cropping," and this translates into less magnification, less graininess, and more sharpness in the reproduction.

The problem of highlight-to-shadow contrast in photographic color art is almost invariably one of too much, rather than too little. There are three factors here that bear comment: film contrast, scene contrast, and contrast control in making color prints.

In transparencies used for reproduction, the slightly higher contrast of Kodachrome 25 is not an advantage. If Kodachrome is your choice, the seemingly lower contrast of Kodachrome 64 would serve you better. In addition, Kodachrome 64, which is 1⅓ stops faster than Kodachrome 25, allows you a greater choice of shutter speeds, a bit of help when the camera *must* be hand-held.

Resist the urge to push *any* film more than a fraction of a stop. (Using Kodachrome 64 at EI 80 is a push of ⅓ stop.) Radically pushed film is often very high in contrast, grainy, marred by a shift in color balance, featureless in the shadows, and soft edged—unsuited for the additional image-degrading effects of color separation and printing.

One type of color art is characterized at times by image contrast that is a bit *lower* than desired—Ektacolor and Ektaflex prints from negatives made on Kodak Vericolor Professional Film. This film is often excellent for portraits and certain industrial applications, but it is too flat for product and similar photography. For increased contrast, with sparkling whites and excellent highlight-tone separation, try Vericolor *Commercial*

To a color separator the transparency from which this reproduction was made is excellent—"a straightforward chrome." It contains colors that can be approximated with process ink pigment combinations, and is a sharp image. Still, the reproduction could not exactly match the art. The major sacrifice was in the highlight end of the scale, where the luminance transmitted through the thinnest part of the chrome far exceeds the amount of light reflected from white paper in a normally lit room. Photograph © 1983, Bill Farrell; courtesy of Colt Industries.

Increasing Detail

Film instead. This color-negative material is currently available in 120 and 220 size rolls and in boxes of 4 × 5 and 8 × 10 sheets. It is Type S (short exposure: 1/10 second or less) and color balanced for daylight. It is not recommended for studio portraits, however; the increased contrast provides a greater apparent sharpness and tends to make subtle skin blemishes very pronounced and objectionable.

Equally important is scene contrast. If you normally shoot transparencies outdoors on bright sunny days or with direct flash indoors, I urge you to reconsider your method. Whereas with black & white film the option exists for abbreviated development to reduce the negative contrast and density range, in the processing of color film the potential for such compensation is minimal. For that reason I suggest reducing image contrast during shooting by using a lower lighting ratio than you would for black & white work. In addition, I recommend off-lens-axis bounce and diffused light sources to hold down contrast and provide essential dimensional modeling. Both indoors and out, use flash fill, white boards, umbrellas, or foil reflectors to illuminate the shadows.

Be aware of the color of bounce surfaces (walls, ceilings, foliage, and other "as is" planes) because these colors, particularly the cool ones, can have a disquieting effect on the color of the image, especially in the highlights and upper middletones.

Outdoors, an overcast day creates better total and local image contrast than a sunny one, but you should be careful to exclude the overcast sky from the shot. It usually reproduces as a flat gray with a hint of cyan, totally uninteresting and lifeless. Obviously, there are occasions when the contrast of a sunny day or similar high-contrast situation cannot be avoided, as when a bright, blue sky is called for in the image. In that case, consider using a color-negative film and making a silver mask (a weak film positive) to be combined with the negative when making the color print. The technique of silver masking to reduce contrast is well documented. Some of the more thorough descriptions and instructions for its use appear in the Kodak Data Book E-66, *Printing Color Negatives*. If you normally make prints directly from transparencies, similar silver-masking data (along with a flashing technique for contrast reduction) appear in Kodak Data Book E-96, *Printing Color Slides* and in Ilford's Cibachrome Laboratory Techniques manual, Technical Data Book 24, *Masking Color Transparencies*.

My suggestion that you use off-lens-axis bounce or diffused flash with reflector fill to reduce image contrast and enhance modeling should also aid in producing meaningful detail at the ends of the scale.

In regard to exposure, we have found that Kodachrome, particularly Kodachrome 64, reproduces with more highlight modeling when it is approximately 1/3 stop underexposed (EI 80). Any slight loss in shadow-tone separation is retrievable during the color-separation sequence. On the other hand, an overexposed Kodachrome is often beyond salvage. The E-6 Ektachrome films record highlight detail well and do not burn out with slight (1/3 stop) *overexposure*. (This was not the case with the earlier Ektachrome emulsions.) The overexposure, of course, opens the shadows a bit.

In all cases, bracketing is recommended, with one change in the customary evaluation procedure. This time, when choosing between bracketed-but-similar transparencies, invite the lithographer in on the decision making. Quite often the transparency that "looks best" to your art director is a bit too weak in the highlights and is not, therefore, the proper choice for separation.

Studying transparencies to evaluate highlight and shadow detail should be done on a light box with a couple of inches of illuminated surface surrounding the chrome. The transparency should not be in a wide black mat, nor should it be examined through a magnifier that shuts out all extraneous light. These devices, designed to minimize flare, provide an

The exquisite shadow values in the transparency from which this reproduction was made, along with the chrome's exceptionally long range and subtle highlight modeling, demanded conventional-scanner separation. Still, shadow differences could not be adequately created within the compressed range of the reproduction without the dot etcher's local manipulation of tone. Photograph © 1982, Lynn St. John.

accurate view of image content but present an inordinately high contrast and perceived range, enhanced image sharpness and shadow-tone separation, sparkling highlights, and extraordinary color saturation—a false preview of how the image will appear on the printed sheet. After all, people rarely look at a printed page in a darkened room with a spotlight on the pictures.

If detail at the ends of the tonal scale is apparent only when the transparency is framed with a wide black mat, or when it is seen from a viewer or projection screen in a darkened room, or viewed through a magnifier that shuts out all light except that transmitted through the chrome, then the range is too great to tolerate the compressing effect of lithographic reproduction. The shadow detail, and perhaps even critical highlight detail as well, will be sacrificed in the reproduction.

Related to highlight and shadow detail are the quality of color saturation and the use of polarizing filters to achieve it. Polarizers are a mixed blessing. On the one hand, properly used, they reduce the effect of glare and provide a degree of color intensity that is often unobtainable otherwise. On the other, they often increase total contrast, and some of the created colors (particularly the color of the sky) are so far beyond the four-color printing-ink gamut that an uninformed client will be sorely disappointed. Therefore, while I recommend the judicious use of polarizers to increase general color saturation and to minimize glare, I must caution you against leading your client to expect what is, in four-color reproduction, impossible.

Earlier, in discussing contact color separations, I spoke of gang separations for a page design that includes a cluster of color images. When the color lab makes the reproduction-size duplicate transparencies for assembly and group separation, the film normally used is Kodak 6121, Ektachrome Duplicating Film. Although it is among the best duplicating films available, it will not provide an image that is a dead match to the original any more than an original transparency is a dead match to a scene. The major shortcoming of 6121 is one of increased total contrast and some loss of local contrast at the ends of the scale—both highlight and shadow detail. We have found that duplicate chromes on Kodak 6121 that have been color balanced to each other and made with a highlight

density of 0.40 (±0.05) and shadow density of 2.50 (±0.10) reproduce best. The overall impression in looking at such a duplicate transparency is that it is too dense in the highlights. Still, highlight tonal *differentiation* is maintained, and lightening the highlights without loss of detail is easily accomplished in color separation and screening.

Of course, when dupes are made and assembled for group separation, it is imperative that they all be on the same type of duplicating film and that the highlight and shadow densities be approximately the same in all the images. Otherwise, either the units will have to be separated and screened individually (negating the value of the dupe-and-assembly altogether) or certain of the images will be sacrificed for the benefit of others.

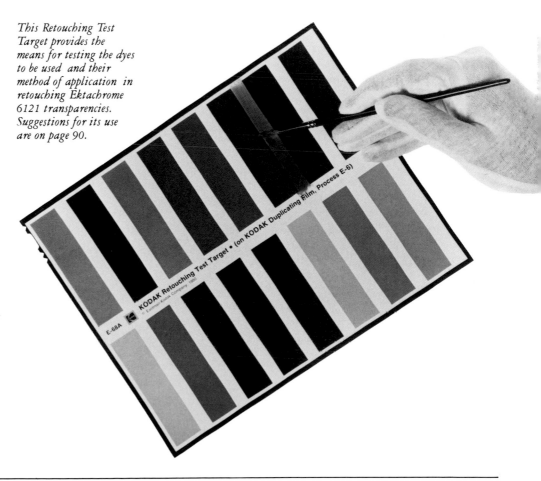

This Retouching Test Target provides the means for testing the dyes to be used and their method of application in retouching Ektachrome 6121 transparencies. Suggestions for its use are on page 90.

For this remarkable image, exposure of the original 4 × 5 Ektachrome was critical. Too much, and the highlight detail would have burned out; too little, and the shadow contrast would have been too low to separate or print properly. Compressing the transparency's range while maintaining shadow contrast—even increasing the shadow-tone separation a bit—was our concern in reproduction. Photograph © 1982, Neal Slavin.

The 4 × 5 transparency from which this separation was made was misleading. It appeared, because of the enormous mass of dark tone, to be an extraordinarily long-range chrome. Measured densitometrically, however, it proved to be a normal-range transparency artfully made to seem extraordinary in total contrast. As a result, dense shadows and highlight modeling were easily maintained in separation. Photograph © 1982, Neal Slavin.

Controlling Color in the Image

Similarly, if prints, rather than transparencies, are being assembled for group separation, they should all be on the same type of photographic paper. It would be unwise to use both Ektacolor and Ektaflex prints in the same assembly.

Incidentally, it is common practice to make a duplicate transparency when retouching is contemplated. This is a prudent approach. But retouching dyes can be a problem. Often, retouched areas color-separate with a markedly different appearance than expected because the chemicals or application method are incompatible with those of the original. One very useful device for pretesting the adequacy of the retoucher's materials and technique when working with Ektachromes—particularly Ektachrome 6121—is the Kodak Retouching Test Target (E-68A). The Target is an 8 × 10 Ektachrome 6121 duplicate transparency on which sixteen shaded patches are aligned in two rows. Twelve of the patches are colors and four are grays of differing density. Alongside each one is a clear area to which matching retouching dyes should be applied. Each space is large enough to accommodate a few brands of retouching mixtures side by side for testing.

After applying the dyes, give the test transparency to your lithographer for separation. A prepress proof will show which of the tested materials and methods are compatible with the image. I strongly recommend that you do not bypass the lithographer's separation and try to complete the test simply by rephotographing the retouched test target on another Ektachrome. Only graphic-arts color separations made on the type of equipment to be used for a project provide reliable data.

The success of color art depends heavily on the photographer's respect for the delicacy of the marvelous stuff that is the staple of his trade—his color film.

The unyielding precision required in manufacturing color film is almost beyond belief. Among countless operations, for example, is the application of three emulsions sensitive to the primary colors of light: red (which ultimately produces the cyan component in the image), green (which produces the magenta layer), and blue (which provides the yellow dye). There are other layers—more than a half-dozen in some films—but consider only these three. Each is about 3 ten-thousandths of an inch thick. That's the aim-point. And, as with any aim-point, there is some variation. If the red-sensitive layer, for instance, is a little too thick, the balance goes toward cyan; a little too thin, the color balance goes toward red. To hold these variations within tolerable bounds, the allowable margin of error in thickness of an individual layer is limited to 5 percent or less. That translates to a deviation tolerance of 15 millionths of an inch in each emulsion layer (applied, incidentally in the dark)!

Add to this the possible variations in materials that go into manufacturing; machine and meter inconsistencies; a variety of shipping and storage conditions; and the all too human "human element," and it is understandable that no two batches of film will be exactly alike. When you buy large-format Ektachrome 64, for example, it may have an effective speed of anywhere between 50 and 80 (plus or minus ⅓ of a stop) and require as much as a CC10 filter to compensate for the potential color-balance deviations that result from manufacturing variations alone.

For predictable, controllable, and consistent color in your work, you

have to buy your film in batches by emulsion number, refrigerate it (the freezer is even better, but in both cases remember the "warm-up time" before use), use filters appropriate to the light source, shoot at speeds that avoid reciprocity-failure effects (often they affect each color layer at a different rate), avoid airport x-ray machines (there is no guarantee that they are operating properly or that the cumulative effect of multiple scans won't destroy your work), process the film promptly after exposure, and, most emphatically, *test the film in advance.*

For a valid test, use exposures and processing that you intend to replicate as closely as possible at the actual shooting. Consider:

- The camera and lens (or lenses) you'll use;

- The speeds at which you expect to shoot;

- The anticipated light on the scene.

The chart on page 93 lists some common light sources and their approximate "apparent" K ratings. It should be remembered that the term "color temperature" in its most technical sense (as a designation of whiteness and spectral composition) applies only to incandescent sources, those which emit light because of their high temperature. Household bulbs are an example of such a source; a metal filament is heated sufficiently by an electric current to emit light measurable in kelvins. But the phrase "*apparent* color temperature" is used

Type of Kodak Color Film Package	Warm-Up Times (Hrs)	
	25°F Rise	100°F Rise
Roll film	½	1
135 magazines	1	1½
10-sheet box	1	1½
50-sheet box	2	3

I selected this photograph for inclusion in this series because it quietly makes a tremendous case for breaking the rules. Normally, a photographer works diligently to neutralize different light sources in a photograph. But, in this case, it is precisely their imbalance that makes the image dynamic. The warm neutral of daylight, the nearly orange of the incandescent light in the clock face, and the lime green of fluorescent illumination in the counter area all contribute to the photograph's success. There was no need to use dot etching to balance the three lights by reducing the orange in the clock and the green in the counter area. Photograph © 1982, Camille Vickers.

This reproduction was created from an 8 × 10 transparency. Contrast was subdued slightly and the overall color balance shifted to a slightly warmer cast to bring the visual impression of the reproduction as close as possible to that of the original image.

It is impossible to match the colors in a transparency, and sometimes a subtle shift in hue, rather than density, is desirable. Such an option requires an aesthetic decision: one reason why the photographer, art director, and printer should confer before the color separation process begins. Photograph © 1983, Arthur Beck.

to specify equivalent whiteness of fluorescent tubes, high-intensity discharge lamps, skylight, etc., although there may be a significant difference in actual spectral composition between incandescent light and other types of illumination. It is this difference—which manifests itself in the Color Rendering Index (CRI)—that may cause color-temperature meters to seem erratic or inaccurate.

I won't comment here on the value of color-temperature meters. You probably know photographers who swear by them and at least an equal number who swear *at* them. In the opinion of some experts, no color-temperature meter small enough to carry is accurate enough to use. I'm certain there are other experts who disagree. Let it suffice that your color meter will prove its adequacy best through use under the varying conditions *you* encounter.

Remember that because storage conditions and age affect film speed and color balance, the exposure and filtration recommendations enclosed in each film package are *only* starting points; for accuracy you must test the film yourself.

Remember that such things as the output of the modeling lights on studio strobes become part of the exposure, affecting color balance on multiple-pop shots.

Remember that office fluorescents are totally unpredictable. They are not all alike, and their color output may change with brand, manufacturing batch, age, room temperature, fixture design, and voltage fluctuation.

Remember that there can be as much as a two-stop difference between meters of the same brand in measuring incident fluorescent light. In the famous words of David Eisendrath, "When the Lord said 'Let there be light,' He evidently was not thinking of fluorescents, for surely they are the work of the devil."

Remember that film is sensitive to ultraviolet (UV) radiation and that the combination of UV output by the light source and UV reflectance of a fabric, for example, will reproduce the colors bluer than they look. Neutral colors will shift most. UV fluorescence, rather than reflectance, affects the high end of the tone scale and may turn a white wedding gown toward blue in the chrome. High reflectance of far red and infrared (IR), where the eye is less sensitive, affects film in another way. In medium- and dark-green fabrics, synthetics in particular, infrared reflectance shifts the greens toward neutral, olive, or even rust.

DuPont Weatherable "Mylar" Type W over the strobes is a good UV absorber, as is a Kodak Wratten 2B filter at the light source or lens. They may not completely eliminate the problem but will significantly reduce it. At this time I know of no filter or other correction for the IR problem, short of postphotography retouching. And sometimes even that is inadequate.

Approximate Apparent Color Temperature of Common Light Sources

Source	Kelvin	Mired Value	Decamired Value
Candle flame	1500	667	67
60 watt incandescent house lamp	2800	357	36
Warm white fluorescent	3000	333	33
500 watt prof. tungsten lamp	3200	313	31
500 watt photoflood	3400	294	29
Cool white fluorescent	4200	238	24
White flame carbon arc	5000	200	20
Mean noon sunlight, Washington, DC	5400	185	19
Light from overcast sky	6800	147	15
Daylight fluorescent	7000	143	14
Blue skylight (subject in shade)	11000	91	9
Light from clear blue sky	25000	40	4

Apparent color temperature is a visual judgement, not necessarily related to specific spectral energy distribution or to its usefulness for precise photographic application. It should be considered only a starting point for photographic tests.

Mired value (MIcro-REciprocal-Degree) is derived from the inverse of the color temperature multiplied by one million (10^6). Therefore, 5000 K = $1/5000 \times 10^6$ = 200 mireds. A more linear relationship exists between mired values than Kelvin values. For example, at 3000 K a decrease of about 50 K is visually apparent. At 5000 K the decrease must be about 200 K to be visually apparent. In each example cited, the change is 5.7 mireds. A decamired number is one-tenth the mired value: 5000 K = 200 mireds = 20 decamireds. Color balancing filters (reddish and bluish) in decamired values are available.

Whenever practical, include a Kodak Color Separation Guide and Gray Scale in a test exposure or in the final shot in a croppable area of the image, lit precisely as is the subject in the photograph. They are made in two sizes: Q-14 is 14" long (Cat. No. 152-7662); Q-13 is 8" long (Cat. No. 152-7652).

The guides serve two purposes. First, comparison of the gray scale in your test transparency to the original scale pinpoints any color shift in the middletones and signals the CC filter required to obtain better color balance during the actual shooting. Second, the guides seen in the transparency reveal deviations from neutral in the gray scale and provide a key to color balance correction during color separation. One warning: like filters, these scales are useful only when they are clean and undamaged. Resist any temptation to use an old set. It can misguide a color separator into destroying the reproduction as he attempts to match your discolored reference to a normal standard set.

A final comment in regard to testing transparency material: it is possible to have a test shooting of Ektachrome processed by a professional lab in a matter of hours. Kodachrome, which requires more intricate processing procedures, usually takes days, although in some larger cities special "rush" facilities are available. If you are called upon to shoot under untried conditions, consider arriving early, shooting a test series for immediate processing at a reputable nearby lab, and doing the final shooting with your test results as a guide. In addition, I suggest that you have the lab that runs your test also do the "for the money" films; in terms of processing results, inconsistency between one lab and another is legendary.

When reviewing your final transparencies for color separation, one more color-balance requirement should be considered. Subtle differences in color balance are often imperceptible on individual transparencies but glaringly apparent and disturbing when several of them are reproduced side by side on the printed page.

For this reason images that are to appear near each other should be examined one at a time and then appraised together as a unit on the light box. Such viewing will point up those transparencies that require a shift in balance, a correction that can frequently be effected by the color separator. The Kodak Color Print Viewing Kit (Publication R-25 Cat. No. 150-0735) allows the photographer to see the effect of color modification on the image and is an excellent device for relaying specific color-balance instructions to the lithographer. A transparency that is more compatible with the others when it is viewed through a 10M filter, for example, should be marked that way.

Marking, incidentally, is made simple through the use of a Quik-Mount—a card made with a transparent pocket for your chrome and space for written comments alongside it. Quik-Mounts are made in various sizes by Photofile, a division of the Data Systems Supply Co., P.O. Box 123, Zion, Illinois 60099.

When the subject of a photograph demands absolute color accuracy, the Kodak Color Separation Guide and Gray Scale are important to both the photographer and the graphic arts cameraman. Examples of images that require great color fidelity in reproduction are those of product packages, such pharmaceuticals as tablets and capsules, cosmetics, and art work such as paintings, pastels, and watercolors. The Kodak Color Print Viewing Kit allows you to provide specific color-shift instructions to the lithographer prior to the color separation operation or when viewing the proof. Language alone is inadequate. "A little bit" means different things to us all.

The 35mm Kodachrome exposure from which this enlarged reproduction was made rivals larger-format films in its ability to maintain detail and texture without being soft-edged and grainy. The camera lens is superb, the lighting sufficiently low-contrast to elude destruction by the increased contrast inherent in Kodachrome. The credit must go to the photographer: she constantly pushes 35mm still-life color photography to its ultimate. . . successfully. The controlled range and textured subject matter make this image an ideal candidate for separation by laser scanner. Photograph © 1980, Peggy Barnett; courtesy of Burlington Industries.

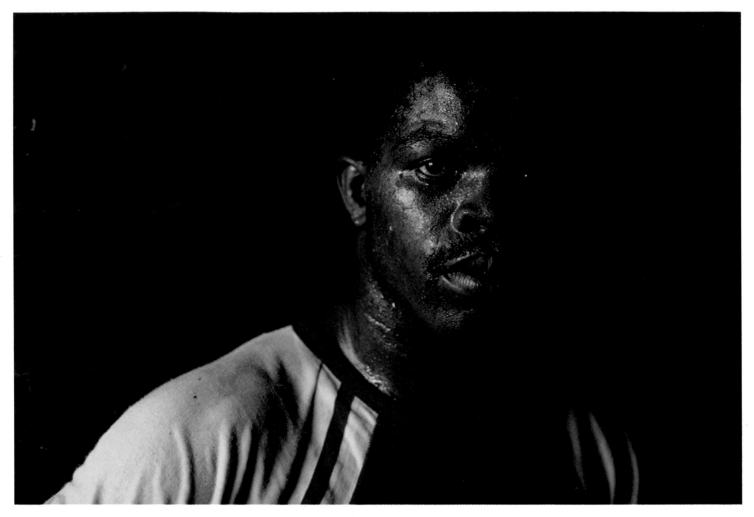

These two portraits demonstrate two vastly different approaches in color separation. The top image is an original Kodachrome: high in total contrast, with a considerable D/max. The lower one is a 35mm duplicate transparency intentionally low in range, with subdued color and edge sharpness. The translation of each to the printed sheet required a distinctly different range compression and sharpness (image enhancement) setting to maintain the mood of the original within the confines of printable color and contrast. These reproductions should serve as a reminder that color separation is a matter of sensitive interpretation of work in another medium. It is not an impersonal, rote procedure. Photographs © 1983, Stephen Green-Armytage.

The Viewing Environment

The care exercised in respect to transparency material should be extended to color-negative material as well. Buy your film—and color-print paper as well, if you make your own prints—in batches by emulsion number, refrigerate it, use appropriate filters, shoot at speeds that don't create reciprocity-failure effects (they may not be "correctable" in the printmaking), avoid x-rays, and process the film promptly after exposure.

Since the final color and color balance are created in the printmaking rather than the film processing, there is far more opportunity to consider options and make color modifications than with transparencies. For a critical color assignment, consider pretesting, then shooting with both color-transparency and color-negative material in much the same way that you might cover a shooting both in color and in black & white. Each has its advantages, and one serves as a backup for the other.

Every professional photographer is aware that radical shifts of color balance occur in transparencies as a result of what seem like minor differences in the color quality of "white" light during exposure. That is recognized as reason enough for scrupulous evaluation of the light on the scene. What is frequently overlooked is that the perceived color balance of a transparency is prejudiced by the color quality of the light in the *viewing* environment, just as the original photograph is prejudiced by the color quality of the light in the scene. It is disheartening to see an art director viewing the work of a meticulous photographer while holding up the transparencies to the nearest overhead lighting fixture or to a window that looks out on a green building with gaudy neon signs. (Alas, there are also those photographers who spend thousands on strobes, color meters, and filters, then "cut down on expenses" by constructing a homemade light box and equipping it with fire-sale fluorescents.)

Since the color of anything depends on the color and intensity of the light incident upon it or passing through it, the appearance of color art varies considerably from one viewing situation to another. And you cannot hope to control the color balance in the reproduction if you, the designer, and the lithographer each examine your images in a different kind of light. To appraise color balance realistically in transparencies or prints for reproduction, to communicate to the printer how you would like the lithographic rendering to appear, and subsequently to evaluate the proofs and press sheets, you have to see both the photographs and the reproductions in a standardized viewing environment that is the same as the lithographer's.

In respect to standards, the American National Standards Institute (ANSI) is very specific: the viewing light (for transparencies and reflection material) should, first of all, have a color temperature of 5000 K. In the case of a transparency viewer, however, it is not enough that the tubes or bulbs be 5000 K. That color temperature must exist at the viewing surface, where the design and materials of the device as well as the light source affect the reading. A homemade light box is no substitute for a 5000 K viewer made by a reputable manufacturer.

Quik-Mount cards protect your transparencies and provide space for important information that may travel along with the chrome throughout its separation and final printing. The name and address of the manufacturer appear on page 94.

In addition to the exact color temperature effective for viewing, other standards apply, including an intensity of about 400 footlamberts at the viewing surface and a Color Rendering Index (CRI) of 90 or more. The CRI is an assessment of the visual effect of a light source on eight specific pastel colors as compared to that of an arbitrary reference source of the same Kelvin temperature. One such source would be a specific variety of daylight. The color rendering of each of the eight colors is compared to its standard and is accorded a numerical grade; then the eight grades are averaged to derive the CRI. The highest average is 100 and varying degrees of deviation move the rating downward on the scale.

The CRI rating is not an independent factor, since it is computed at a specific color temperature. A CRI of 90 at 5000 K does not produce the same effect as a CRI of 90 at 7500 K. For this reason, both Kelvin temperature and CRI are linked (5000 K with a CRI of 90) in designating a particular kind of light.

Full particulars regarding criteria for the viewing environment are available from the American National Standards Institute, 1430 Broadway, New York, N.Y. 10018. Ask for Standard PH2.31-1969, *Direct Viewing of Photographic Color Transparencies.*

Incidentally, since at 5000 K a change of even 200 K (approximately 6 mireds) is perceivable, the use of a conventional slide projector (approximate color temperature of the lamp: 3400 K, a difference of 94 mireds) is not suited to critical evaluation of color quality as it relates to separation and reproduction. Transparencies become far cooler in reproduction than they appear when thrown on the screen from such a projector, and any lack of image sharpness is camouflaged by the high intensity of illumination. One of the few 5000 K (90 + CRI) transparency projectors available is made by Macbeth Corporation, Newburgh, N. Y. 12550. The unit is made to conform to ANSI Standard: PH2.45-1979, *Projection Viewing Conditions for Comparing Small Transparencies with Reproductions.* It is about the size of the proverbial bread box, accommodates only 35mm transparencies, and has a fixed magnification of about 6× and a self-contained screen. Although its color temperature and CRI meet the standard, accurately translating what you see in terms of recordable contrast, color saturation, and detail involves an extended learning process. This device, which requires sophisticated interpretation and limits magnification, is obviously not of great value to everyone.

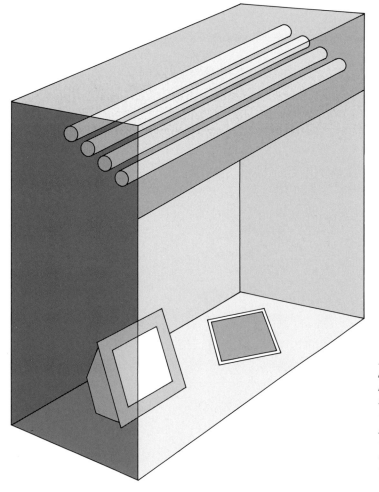

A standardized viewing device is not a frill, a luxury, or an expense. It is an investment that can contribute as much to a photographer's success as any other piece of photographic lighting equipment.

Transparencies vs. Prints

Color prints and press sheets also must be judged in a 5000 K (90 + CRI) light. The ANSI brochure PH2.32-1972, *Viewing Conditions for the Appraisal of Color Quality and Color Uniformity in the Graphic Arts Industry* provides detailed information including a recommended light level of approximately 200 footcandles at the viewing surface. Fluorescent tubes that meet the standards of apparent 5000 K and CRI of 90 or more are available from Macbeth Corporation, from The DuroTest Corporation, 2321 Kennedy Blvd., North Bergen, N.J. 07047, and from General Electric Co., Lamp Business Division, Nela Park, Cleveland, Ohio 44112. In addition, Macbeth Corporation is one of the manufacturers of a viewing booth: a tabletop controlled-lighting environment for viewing reflection copy and, with the addition of a transparency illuminator, for comparing transparencies to prints and press sheets. All these manufacturers provide descriptive material about their products on request.

Again, a standardized viewing condition is as important as a common language: with it, there is opportunity for intelligent, extended communication between photographer or designer and lithographer; without it, there is confusion, frustration and, often, failure.

As I mentioned earlier, an enormous proportion of the color art submitted for reproduction is transparency material. As a result, lithographers know more about handling problem chromes than problem color prints. For some art directors, this is reason enough to continue to submit transparencies on virtually every occasion in which color art is part of the job. But this logic reinforces a self-perpetuating condition: "We do it that way because we always do it that way!" which is at best restrictive, and at worst destructive, to the purpose of a printed piece.

In the long run, it will improve the reproduction quality of your work if you keep an open mind and, for each assignment, weigh the relative advantages of transparencies and prints. Each has its strengths and limitations; neither is ideal in all cases. Remember that options do exist; "because we always do it that way" often is simply an excuse for not thinking.

When dealing with an uninformed client, both photographers and printers often prefer transparencies. For the photographer, transparencies have a sparkle and saturation that instantly make them more interesting and more saleable. They look sharper than prints and, because there are fewer processing steps in making a transparency, they cost less and are available for viewing sooner than prints. Some lithographers have found that clients accept more readily that the equivalent range, local contrast, and color saturation of a chrome are unattainable on the

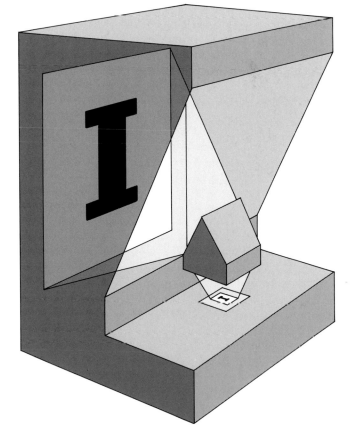

The 35mm transparency viewer that is the industry standard differs from a conventional slide projector in color temperature, intensity, and Color Rendering Index of the light source. The viewer is limited to one magnification and one viewing screen.

printed sheet and are more lenient in their demand to "match art" than when color prints are used. In addition, transparency material allows the separator to use any of the four devices available—camera, enlarger, contact frame, and scanner—rather than only the camera or the scanner, as is the case with color prints.

But transparencies, for all their vivacity, are not without limitations. Among the most significant is that their extended color gamut and range, which make them so dynamic, are far beyond those of printing. Consequently, only experience can provide the ability to evaluate the potential of a given transparency for reproduction; only daily comparison can train the eye to be critical, objective, and able to determine whether a given chrome will translate adequately to a four-color printed sheet. Limited experience is responsible for much of the unhappiness that often occurs among the partners in a common effort— photographer, art director, and printer.

Add to this the fact that the human eye is more limited in its sensitivity to colors at the ends of the visible spectrum than film is. We see as the same, for example, certain reds that both the transparency and the filtered color-separation film respond to as "different." As a result, the entire effort of color match to a transparency becomes a compromise inclined toward an interpretation and perception that is often not akin to your own.

Particularly limiting to the photographer is the fact that the color balance of the transparency is virtually locked in at the time of shooting; the routine but

extraordinarily helpful darkroom options of dodging and burning-in are not available with an original chrome, and retouching cannot be as extensive as it can be with a print. Let me remind you, if retouching is planned, to be sure that the chosen dyes have been made to match the dye sets of the specific transparency material and that they are used precisely as directed. Others may visually serve the purpose but separate differently, thereby creating expensive, time-consuming, and often insurmountable salvage problems.

In addition, original transparencies are often one-of-a-kind and the potential for loss, damage, or change in the color-dye layers caused by age, poor storage conditions, or extended projection is undeniable.

Among other hazards, the glass mounts in popular use are particularly dangerous to the transparencies. Glass, cracked in shipping and handling, can scratch or gouge an emulsion beyond repair. For separation, transparencies must be removed from their mounts anyway, so that contact masks may be made or so that they may be positioned on a scanner cylinder. Prying open and handling these fragile glass sandwiches invites disaster.

Moreover, small chromes are usually "floated in oil"—given a light coat of mineral or similar oil—in preparation for scanner or enlarger separation. This reduces the possibility of creating Newton's rings and mini-mizes the effect of surface scratches on the chrome. The oil is removed be-fore the transparency is returned to you, but the extra handling, no matter how careful, certainly can't do a one-of-a-kind transparency any good.

Removed from their mounts, small transparencies are even more susceptible to loss, more difficult to assess, and more vulnerable to the destructive effects of surface abrasion and dust.

In short, even relying upon the most meticulous care in separation, it is naive to think that transparencies that have been handled by over a dozen people (albeit gentle and considerate ones) and their machines will be returned to you in first-rate condition.

If transparencies are preferred in spite of these limitations, it is prudent to have back-up art available. I recommend that in addition to bracketing you consider *shooting duplicate originals*. It is the fastest, cheapest, and easiest way of creating an accurate duplicate and solves the dilemma of one-of-a-kind transparencies.

Color prints, on the other hand, are usually not as precious. If a color negative or dye-transfer separations or matrices exist, another print can be made now, or years from now.

One of the most significant advantages of a color print is the medium itself: reflection copy is more closely related to the range and local contrast of the intended reproduction than a transparency. On the one hand, it is not as enticing as a chrome; on the other, it is not as misleading.

Prints are usually furnished up-size— larger than they will reproduce— making image sharpness and color quality easier to judge. Dodging and burning-in, as well as altering total density, are possible, and the printmaker can even shift local color with the help of small, irregular chips of a chosen CC filter attached to the

Color Print Reproduction

end of a dodging rod. In addition, masks for contrast reduction are a practical option, producing reproduction-quality prints that are more realistic, cost less, and are available sooner than heavily retouched ones.

If extensive retouching *is* necessary, it is possible to a degree that significantly exceeds what can be done on transparencies. Be aware of, and avoid, retouching dyes that fluoresce. They can have a destructive effect on color, smoothness of tone, and local contrast. If a print has been retouched with fluorescent materials, the cameraman can use special filters at the lens or over the light source to reduce the problem, but the technique is not always totally effective.

While precise filter adjustments are required to cope with manufacturing and storage variations of transparency material, with color-negative stock this effort is usually unnecessary. Certainly since Vericolor, Type S, is balanced for daylight, and Type L for 3200 K, conversion filters are recommended. But minor variations in the apparent color temperature of light that must be accounted for in a color transparency exposure can be overlooked in a color-negative exposure and then accommodated with simple and effective measures in the printmaking.

For crucial color match to a product package or room decor, I recommend that a "reference frame" be shot that includes a Kodak Gray Card (R-27) that appears at least ⅜" square in the negative. It provides the darkroom technician with a useful visual guide and densitometric reference patch from which he can make filter-pack and exposure determinations for printmaking.

Four final suggestions: First, Eastman Kodak, in the recently revised edition of Publication F-20, *Graininess and Granularity*, states that Vericolor films are made with emulsion layers of two levels of graininess, and that "...increasing exposure (up to a point) places more of the density in the finer-grained layers, which actually reduces the graininess of the images as the densities are increased." This translates to a recommendation for slight overexposure of this color-negative material for a less grainy, sharper looking print, a print better suited for color separation.

Second, before making your final color prints, confer with your lithographer regarding print size. Although camera copyboards can accommodate color art 30 × 40 inches and larger, among the well known brands of scanners, one can accommodate prints only 10 × 12½ inches or smaller, and another handles color art up to 16 × 20 inches.

Third, do *not* mount your color prints. If you do, separation can be done only with the camera; unmounted prints can be wrapped around a scanner drum and separated. Since there are occasions when a scanner is better suited to the subject matter, you should keep that option open.

Last, if a dye-transfer print is to be supplied, it should be made larger than it will reproduce. As you know, the dye-transfer process involves at least three separate dye-image transfers to the mordanted paper, and a slight misregister within the composite dye image may result. In enlargement of the dye-transfer print, the misregister is also enlarged and usually becomes quite noticeable. Avoid the risk; make dye transfers up-size except when the anticipated use of a scanner places a limit on image size. In such a case, the decision should be made in consultation with your lithographer.

Color negatives alone as copy for the color separator are a possible option, but they are a risky business. They are one-of-a-kind; they are impossible to assess in terms of color balance; they rule out your dodging and burning-in options; and they provide no significant gain in sharpness over a reproduction-size print or transparency made from the negative. The gamble is so great that many lithographers refuse to separate color negatives. A print or an Ektacolor transparency made from the color negative is preferable because it provides the lithographer with a specific measurable reference and precludes the possibility of accidental loss of the original image.

Avoiding Costly Image Mishaps

Often, color art meets the technical criteria described here and still is either completely unsuitable for use or costly to salvage. Be particularly alert to potential problems and, if possible, solve them at the time of the shooting. The extra care—the ounce of prevention—will probably take a bit more time, but is guaranteed to result in a greater number of usable images. Typical of the recurrent problems that are either costly or impossible to correct in color separation are the following:

Five O'Clock Shadow. Male executive portraits shot late in the day are often marred by the appearance of a blue-purple tone in the moustache and beard area. It is difficult if not impossible to completely correct this, and the tone often becomes even more pronounced in the reproduction. Shoot early in the day.

Frayed or Ill-Fitting Collars. Check for unsightly necklines that can destroy a portrait. Adjustment of the tie or a pair of scissors to snip off loose threads before shooting is all that's needed. I leave the matter of tact to you.

Extremely Dark or Pin-striped Clothing. Suits and skirts made of very dark or pin-striped fabrics create tone-reproduction and press problems out of proportion with their importance. Solid colors other than black are a better choice.

Clothing "Fatigue." Few people look freshly groomed after a long day's work. Again, shoot early, before lap creases and other clothing wrinkles appear and shirt collars wilt or curl.

Too-Legible Lettering. Keep in mind that unless indirect separations are made, attempts to "greek out" lettering—make it illegible in the screened printers—often look crude and heavy-handed. So, to obscure lettering on machinery or license plates and obliterate price marks on products, consider masking or covering them at the time you make the photograph.

Litter, Clutter, and Just Plain Dirt. Reducing desk and wall clutter, removing traces of oil drippings on machines, or toning down cigarette butts and other floor litter in the separation stage is costly. But before your assistant sweeps the scene prior to shooting, check with a supervisor. No matter how small the area is, by tidying it up you may be violating a custodial-union contract provision. The same applies to changing even one light bulb. Get it done, though you may need a special someone at the site to see to the details.

Health and Safety Violations. Be aware of requirements regarding work shoes, helmets, gloves, and goggles, or have someone nearby who is aware of them and can clear the shot of a particular person, machine, or work area before the shooting. We have seen wonderful chromes rendered unusable because safety shields were momentarily removed from machinery. Sometimes discovery of the pictured violation isn't made until the color proofs are viewed. That's expensive and should be embarrassing to a seasoned photographer.

Cellophane Wrappers. Transparent wrappers and cellophane-covered die-cut windows in packages often show up as opaque white areas rather than transparent ones where they appear in a chrome. If appropriate, remove the wrappers and cut the cellophane out of the package windows for a better result.

Problem Fabrics. Small, tight patterns in clothing or furniture fabrics when combined with the halftone screen pattern may cause a moiré. Since the moiré is dependent in part upon the pattern's precise color, size, and direction in its reproduction and the fineness of the halftone screen, it is often impossible to predict at the time you do the original photography. The safest procedure is to avoid small patterns altogether, if possible.

Dirty and Bitten Fingernails. Cleaning fingernails in separations is expensive; creating longer nails is a job for a retoucher. In either case, anytime after shooting is the wrong time to solve the problem.

The "Invisible" Elements. These are the small but disconcerting items that are so normal in the scene that they are overlooked by the casual or hurried observer. In spite of their tendency to elude notice in their natural setting, they are glaringly apparent in the transparency and limit the use of your work. A wall calendar, for example, may prematurely date an otherwise long-lived image. The appearance of cigarettes may be contrary to company policy. Cracked or dirty window panes, open clothes closets, oh-so-cute bumper stickers, puddles that betray a poor drainage condition, window reflections (including those of your flash tube or umbrella), stained work uniforms, large wall thermostats, rusty pipes, strings connected to overhead lighting fixtures, and your own meter or film wrappers are just some of the items that fall into this category. The best solution is to make a studied examination of the scene to be photographed. Yes, it takes time. Yes, it usually reveals "invisible" elements, and yes, it is much better to remove or compensate for them at the time of the shooting than to be embarrassed by their appearance as problem art afterward.

On occasion a tight repetitive pattern in a photograph may combine with the repetitive pattern of the halftone screen to produce an interference design called moiré. Although changing screen fineness or angle, or altering reproduction size of the image may eliminate the problem, it is best to avoid moiré-prone subject matter whenever possible.

65-screen *150-screen* *200-screen*

Conclusion

Most lithographers approach color separation and reproduction determined to produce excellent work. When they succeed, it is exciting and gratifying; when they do not (often for reasons related to the limits of current technology), there is a lasting sense of personal failure. Printers are neither stupid nor hostile. But to do a better job for you they need your help—color art that is suitable for color separation. I urge you to use the information presented here as the basis for reexamining your methods. Use it, too, as a key to the door that is now often closed to photographers, the door behind which the art director and the lithographer discuss the work to be printed—in part *your* work—and review the final result. You should be there.

It is sad that in an industry built upon communication there is so little of it among its practitioners. The lithographer wants to talk to you before the shooting, when final art is selected, and after the work is printed. He also needs to hear what you have to say. *That* is where excellence of color on the printed page begins.

I recognize that there are photographers who do not choose to help. Their stand is: "I've had enough trouble making the shot; now it's your problem." That view is equivalent to our both being in a boat that has a leak near where I'm sitting. The same man would reason: "Why should I help bail? After all, it's *your* end of the boat."

I agree that it is not his problem. But neither is it mine. It is ours.

My objective here has been to offer you practical information about color-separation and reproduction techniques as they relate to your color photography. Such subjects as subtractive color theory, in-depth analysis of masking techniques, comparisons of exotica among brands of electronic scanners, dot etching, dry etching, and other film-altering techniques, and such press considerations as printing-ink chemistry and ink trap, all of which affect the printed image, are beyond the scope of this discussion. For those who wish to extend their knowledge in these specialized areas, a list of recommended texts and manuals follows.

In proposing this body of reference material, I am trying to tell you something of great significance. Lithography is not a mindless, mechanical, assembly-line trade, but rather a refined and demanding craft that will serve your interests in proportion to the respect you show for it. Consult the books and articles and pamphlets if you care to, but *above all consult your lithographer*, a professional who should be regarded as an ally and advisor, not as an adversary.

Bibliography

Burden, J.W., *Graphic Reproduction Photography*; New York, New York: Hastings House Publishers, 1980.

Chambers, E., *Reproduction Photography for Lithography*; Pittsburgh, Pennsylvania: Graphic Arts Technical Foundation, 1979.

Cogoli, John, *Graphic Arts Photography: Black and White*; Pittsburgh, Pennsylvania: Graphic Arts Technical Foundation, 1981.

Gatehouse, A.L., and K.N. Roper, *Film Assembly and Platemaking*; Pittsburgh, Pennsylvania: Graphic Arts Technical Foundation, 1980.

Halpern, B., *Color Correction for Offset Lithography*; Pittsburgh, Pennsylvania: Graphic Arts Technical Foundation, 1964.

Hartsuch, P.J., *Chemistry for the Graphic Arts*; Pittsburgh, Pennsylvania: Graphic Arts Technical Foundation, 1979.

Jaffe, E., Brody, E., Preucil, F., and White, J., *Color Separation Photography for Offset Lithography*; Pittsburgh, Pennsylvania: Graphic Arts Technical Foundation, 1959.

Jaffe, E., *Halftone Photography for Offset Lithography*; Pittsburgh, Pennsylvania: Graphic Arts Technical Foundation, 1964.

Jaffe, E., and R.F. Reed, *The Science of Physics in Lithography*; Pittsburgh, Pennsylvania: Graphic Arts Technical Foundation, 1964.

Latham, C., *Advanced Pressmanship*; Pittsburgh, Pennsylvania: Graphic Arts Technical Foundation, 1963.

Mannheim, L.A. (ed.), *The Focal Encyclopedia of Photography*; New York, New York: Focal Press, 1965.

Mees, C.E.K., and T.H. James, *The Theory of the Photographic Process*; New York, New York: The Macmillan Company, 1966.

Porter, A.S., *Lithographic Presswork*; Pittsburgh, Pennsylvania: Graphic Arts Technical Foundation, 1980.

Reed, R.F., *What the Lithographer Should Know About Ink*; Pittsburgh, Pennsylvania: Graphic Arts Technical Foundation, 1964.

Sanders, N., *Graphic Designer's Production Handbook*; New York, New York: Hastings House Publishers, 1982.

Shapiro, C. (ed.), *The Lithographers Manual*; Pittsburgh, Pennsylvania: Graphic Arts Technical Foundation, 1980.

Southworth, M., *Color Separation Techniques*; Philadelphia, Pennsylvania: North American Publishing Company, 1975.

Sturge, J.M. (ed.), *Neblette's Handbook of Photography and Rephotography*, 7th ed.; New York, New York: Van Nostrand Reinhold Company, 1977.

Todd, H.N., and R.D. Zakia, *Photographic Sensitometry*, 2nd ed.; Dobbs Ferry, New York: Morgan and Morgan, 1974.

Wentzel, Fred, *Graphic Arts Photography: Color*, Pittsburgh, Pennsylvania: Graphic Arts Technical Foundation, 1983.

Yule, J., *Principles of Color Reproduction*; New York, New York: John Wiley & Sons, Inc., 1967.

Smaller Publications

Advances in Color Reproduction; Pittsburgh, Pennsylvania: Graphic Arts Technical Foundation, 1973.

Camera-Back Silver Masking with Three-Aim-Point Control; Kodak Publication Q-7B, Eastman Kodak Company, 1976.

The Color-Separation Scanner; Kodak Publication Q-78, Eastman Kodak Company, 1981.

Correcting Ganged Transparencies for Color Reproduction; Kodak Publication Q-132, Eastman Kodak Company, 1975.

Direct Screen Color Notes; Kodak Publication Q-500, Eastman Kodak Company, 1975.

Fundamental Techniques of Direct-Screen Color Reproduction; Kodak Publication Q-10, Eastman Kodak Company, 1980.

Graphic Arts Handbook, Vol. 2; Wilmington, Delaware: Photo Products Department, E.I. DuPont De Nemours & Co.

Halftone Methods for the Graphic Arts; Kodak Publication Q-3, Eastman Kodak Company, 1982.

Kodak Bulletin for the Graphic Arts; Nos. 5, 10, 11, 15, 19, 24, 26, 28, 30, 35, and 37, Eastman Kodak Company, 1964 through 1979.

Light and Color; General Electric Publication TP-119, General Electric Company, 1974.

More Special Effects for Reproduction; Kodak Publication Q-171, Eastman Kodak Company, 1977.

The Relations Between Dot Area, Dot Density, and Tone Value in Lithography; Pittsburgh, Pennsylvania: Graphic Arts Technical Foundation, 1960.

Research Reports; Pittsburgh, Pennsylvania: Graphic Arts Technical Foundation:

- #137: A color chart for representing process ink gamuts, 1970;

- #143: Evaluation of lightness and color balance of color transparencies, 1971;

- #144: A practical approach to gray balance and tone reproduction in process color, 1972;

- #149: Errors in color calculations due to fluorescence, 1973;

- #154: Masking and color reproduction, 1972.

Silver Masking of Transparencies with Three-Aim-Point Control; Kodak Publication Q-7A, Eastman Kodak Company, 1980.

Two Stage Masking; Wilmington, Delaware: Photo Products Department, E.I. DuPont De Nemours & Co.

Index